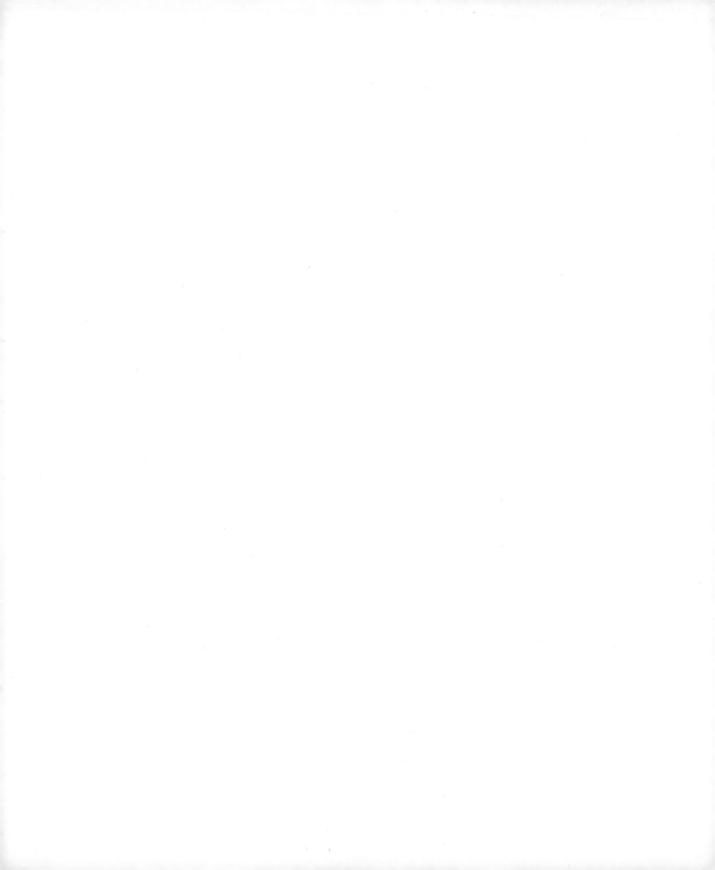

Edvard Munch

Masterpieces of Art

Publisher and Creative Director: Nick Wells
Project Editor and Picture Research: Laura Bulbeck
Art Director and Layout Design: Mike Spender
Digital Design and Production: Chris Herbert
Copy Editor: Ramona Lamport
Proofreader: Amanda Crook
Indexer: Helen Snaith

Special thanks to: Catherine Taylor, Frances Bodiam and Helen Crust

FLAME TREE PUBLISHING
Crabtree Hall, Crabtree Lane
Fulham, London SW6 6TY
United Kingdom

www.flametreepublishing.com

First published 2015

15 17 19 18 16
1 3 5 7 9 10 8 6 4 2

© 2015 Flame Tree Publishing Ltd

A CIP record for this book is available from the British Library upon request.

Image credits: © Artothek: 82 , 93, 119 and the following contributors: IMAGNO 53 , 61, 121; Blauel 66; LWL-MKuK –
ARTOTHEK 92, 107; Hansmann 110; **© Bridgeman Images** and the following: Bymuseum, Oslo, Norway 30; Munch-
museet, Oslo, Norway/De Agostini Picture Library/M. Carrieri 32, 71, 90, 101; Rasmus Meyers Samlinger, Bergen,
Norway 33, 39, 49, 54; Private Collection 34, 36, 43, 44, 75, 97, 98, 102; Kommunes Kunstsamlinger, Oslo, Norway 37,
122; Nasjonalgalleriet, Oslo, Norway 38; Private Collection/Photo © Christie's Images 41, 68, 100, 111, 112, 114;
Fogg Art Museum, Harvard Art Museums, USA/Gift of Rudolf Serkin 42, 45; National Museum, Oslo, Norway 48, 76, 88,
117; Christian Mustad Collection, Oslo, Norway 51; Nasjonalgalleriet, Oslo, Norway/Index 58; Munch-museet, Oslo,
Norway/Index 59; Bergen Art Museum, Norway 63, 67, 91; Nasjonalgalleriet, Oslo, Norway/De Agostini Picture Library/M.
Carrieri 65, 85; Private Collection/De Agostini Picture Library/M. Carrieri 78, 83; Munch-museet, Oslo, Norway 79, 115,
118, 120; Van der Heydt Museum, Wuppertal, Germany 86; Kunsthistorisches Museum, Vienna, Austria 87; Lubeck
Museum, Germany 94; Mielska Gallery, Stockholm, Sweden 95; Sonia Henie Collection 123; Nasjonalgalleriet, Oslo,
Norway 124; **© Superstock** and the following: Christie's Images Ltd 31; Peter Barritt 74; Album/Oronoz/Album 84;
© 2015. Photo Scala, Florence: 60, 72, 106, 125; **© akg-images**/Erich Lessing: 108; and courtesy of **Google Cultural
Art Institute** and © the respective museums: 40; 50; 56; 57; 62; 64; 69; 70; 73; 96; 99; 103; 113; 116 and courtesy
of Wikimedia Commons/public domain: 52 .

ISBN: 978-1-78361-356-4

Printed in China

Edvard Munch
Masterpieces of Art

Candice Russell

FLAME TREE
PUBLISHING

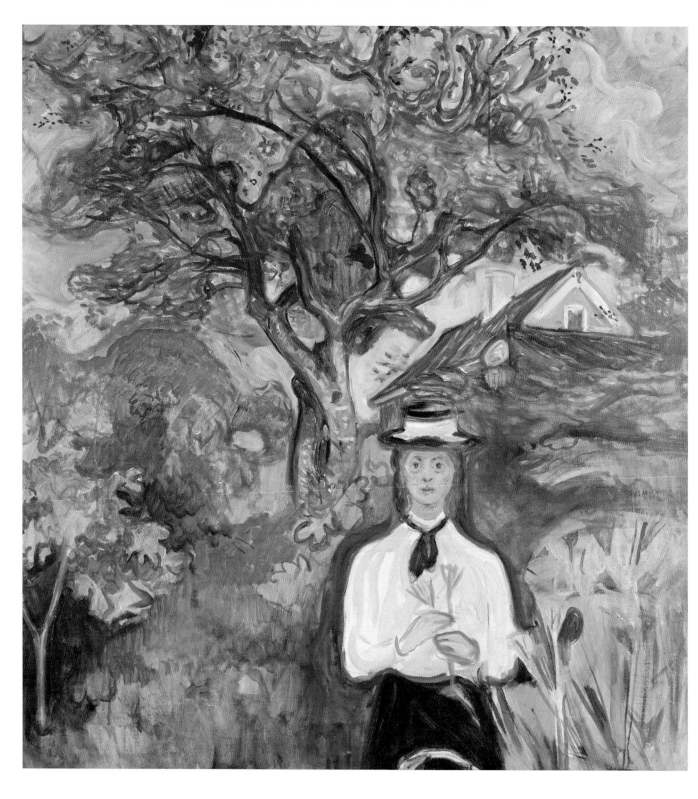

Contents

Edvard Munch: Living Colour

*T*he most famous Norwegian painter, Edvard Munch (1863–1944) has been remembered primarily for one work. *The Scream*, 1893 (*see* page 52) with its ghostlike figure in open-mouthed horror at the sound coming from his/her own mouth, has been popularized, transmuted and universally praised for its depiction of modern man's existential loneliness. But there is so much more to the work of this deeply intellectual man who battled challenges such as addiction to alcohol and mental illness. While Munch's compelling personal story makes him understandable as someone who suffered and sacrificed for his art, his body of work as an experimenter and chronicler of life in all of its beauty and horror compel a deeper appreciation of his genius.

Munch sought out other forms of art, namely reproductions through lithography, woodcuts and etchings, because he wanted more people to see it. His mission was to tap into personal experience and convey it as a physical piece of art. His hope was to awaken a profound subjective response in the viewer.

Childhood Years

Edvard Munch was born on 12 December 1863 in a farmhouse in the village of Ådalsbruk in Løten, Norway, to Laura Catherine Bjølstad and her husband, Christian Munch, a doctor twice her age. He had an older sister, Johanne Sophie, and three younger siblings – Peter Andreas, Laura Catherine and Inger Marie. Only two of the five manifested artistic talent – Johanne Sophie and Edvard, presumably inherited from their mother, who enjoyed artistic pursuits such as embroidery, painting furniture and dancing.

The family moved to Christiania, now Oslo, in 1864 when Munch's father was appointed medical officer at Akershus Fortress. Despite his profession, the family struggled financially and moved frequently. In Edvard's adolescent years, each uprooting to a new domicile was dingier and more unpleasant than the last.

A troubled childhood beset by illness, death and upheaval set the stage for the development of Munch's neuroses, which plagued him for most of his life and inspired so much of his art. His mother died of tuberculosis in 1868, and his mother's sister, Karen, moved into the household to take over child-rearing and domestic chores. Edvard and his beloved sister Johanne Sophie became extremely close, but she died, aged 15, of the same illness as their mother in 1877.

Edvard was a sickly child, especially in winter, suffering from chronic asthma, bronchitis and rheumatic fever. However, despite missing so much regular schooling, his education was steadied with the help of classmates and his father, who taught him history and literature. To entertain himself in his sickbed on those cold, dark days, the boy turned to drawing and watercolour painting. By his teen years, art was his main focus. His aunt, Karen, recognized his talent at the age of seven when she admired his drawing of blind men. His cousin Ludvig Ravensberg (1871–1958) had a childhood memory of Edvard's sketchbooks: 'In his little paintings I could see many of the districts and strange houses that we had passed on the way. And then there were all the drawings of the family going about their daily life in the house.'

At the age of 13, Edvard saw the work of the Art Association and favoured the paintings of the Norwegian landscape school that he tried to copy. Then he turned his attention to oil painting. Socially isolated and suffering from a weak constitution, Edvard watched his sisters who were sent to beg from rich relatives when finances were especially tight. He wrote, 'I came frightened into the world and lived in perpetual fear of life and of people.' But those neuroses oddly nourished him, too. The trying experiences of his childhood led the artist to repeatedly explore in his art the themes of anxiety, emotional torment, and mortal vulnerability to illness and death, as well as the attraction and repulsion of human sexuality.

The Sick Child

In the autumn of 1882, Munch rented a studio in Christiania with a group of artists and exhibited the full-length portrait *Inger in Black* at the World Exhibition in 1885. He also showed at the annual Autumn Exhibition in Christiania the next year and was pejoratively dubbed an anarchist and Impressionist.

It was at this time that Munch created the first of many versions of *The Sick Child* (for the 1886 version, *see* page 48). Based upon the illness and death of his cherished sister, Sophie, as well as visits to the sick and dying with his doctor father, this heavily emotional experience for Munch came to inspire at least 20 different versions. Although at one point he called it 'a thoroughly nervous, cubist and colourless

picture', he also recognized that it marked a change in his art. But when it was shown in the Autumn Exhibition in Christiania in 1886, people stood in front of it and laughed without appreciating the child's bravery and stoicism along with its depiction of the fragile quality of life. Munch, however knew it presented 'a breakthrough in my art'.

It certainly represented a change: 'I began as an Impressionist but it was limited and I had to find another way of expressing the emotional turmoil I experienced during that bohemian period of my life. My association with [Hans] Jaeger helped – (paint your own life). *The Sick Child* was the first break from Impressionism.'

Pietism

Munch was profoundly and negatively influenced by his father's
Christian fundamentalism. After his wife died, Dr Munch reacted in
a disturbing manner to his children's misbehaviour. He said that their
actions were causing their mother to grieve in heaven, as if she were
some omniscient and punitive overseer.

Munch wrote: 'My father was temperamentally nervous and obsessively
religious – to the point of psychoneurosis. From him I inherited the
seeds of madness. The angels of fear, sorrow and death stood by my
side since the day I was born.'

Christian Munch beat his children for their perceived indiscretions. But
he also had a tender side. Edvard noted that his doctor father had a fear
of blood and would have been more temperamentally suited to being a
poet than a man of medicine. 'When father was not in the grip of a
religious attack, he could be like a child himself, teasing and playing
with us, having fun and telling us stories. This made it doubly horrible
when he punished us, beside himself with the intensity of his violence.'

The decision that Munch made to be an artist in 1880 was met with
paternal disdain, as Dr Munch perceived art to be an 'an unholy trade'.
Even neighbours wrote letters and notes of disapproval about the elder
son's unfortunate choice of profession. But Munch persevered with a

stalwart purpose in mind, writing in his diary, 'In my art, I attempt to explain life and its meaning to myself.' If he could help other people in the process, it underscored the rightness of the endeavour.

Though his father was a man of science, he had an unscientific explanation for the prevalence of so much illness and death in his family, attributing the incidence of both to divine punishment for sins or misdeeds unspoken and unidentified. Dr Munch also believed that God was responsible for all human activity and that all people carried the burden of original sin. Heaven was reserved only for people with deep religious feeling, though he could not convince Edvard of his beliefs.

With these facts in mind, it is no wonder that religion would never be a source of comfort to which Munch would turn for answers about life. But, in his own, non-church-going way, the artist maintained a spiritual belief – if not faith in God – in forces larger than himself operating in the universe.

Starting His Studies

In 1879, Munch began studies in engineering at a technical college. While he did well in physics, maths and chemistry, frequent bouts of illness interfered with his studies. He left the school in 1880 with the intention of becoming a painter, and in 1881 enrolled at the Royal School of Art and Design of Christiania, one of whose founders was a distant relative, Jacob Munch (1776–1839). His teachers were sculptor Julius Middelthun (1820–86) and naturalist painter Christian Krohg (1852–1925). Munch's first public showing of his art in 1883, a full-length portrait of the bohemian Karl Jensen-Hjell (1862–88), sparked the wrath of one critic: 'It is impressionism carried to the extreme. It is a travesty of art.'

Impressed by Impressionism

There is debate about which Impressionist and post-Impressionist artists and paintings Munch saw in France when he went to study there, courtesy of a grant, in 1885. Yet there is agreement he was exposed to the paintings of Vincent van Gogh (1853–90), including *Starry Night* (1889), Henri de Toulouse-Lautrec (1864–1901), Camille

Pissarro (1830–1903), James Whistler (1834–1903), Claude Monet (1840–1926), and Edouard Manet (1832–83). The Impressionists, who showed their work together during the 1870s and 1880s in France, adhered to certain principles by using small, thin, visible brushstrokes, open composition, depicting light accurately, using ordinary subject matter, and striving for unusual angles. Post-Impressionist artists used vivid, sometimes unnatural colours, the thick application of paint, and the distortion of form for effect and treatment of real-life subject matter.

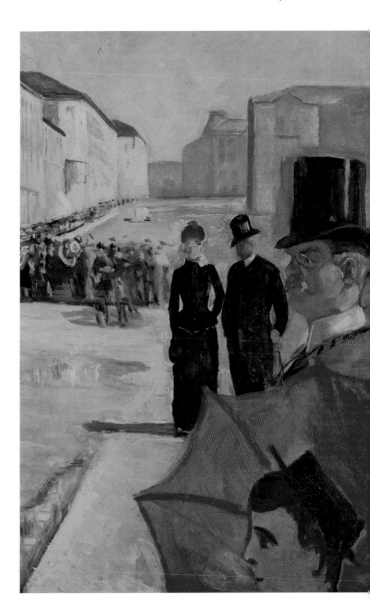

While his open-air paintings in France show the Impressionist influence, in terms of subject matter and depictions of sunlight on water, Munch was also influenced by Naturalism, Symbolism, Realism and Syncretism, which sought to give form to inner visions, all of which he used and transformed in order to express something different and deeply personal.

Munch eventually lost his respect for the Impressionist approach and subject matter, which he thought was superficial, seeking instead to probe and reveal what was beneath the surface. He derogatively called Impressionism 'soap art'; his goal, by contrast, was 'soul art'. Munch embarked on a rigorous self-examination of his own psychological state during key moments of his life, such as the last stroll he took with his mother. He developed his own iconography, with colours expressing what he thought and felt, in order to build a bridge of receptiveness to those who would see his paintings and respond in their own way.

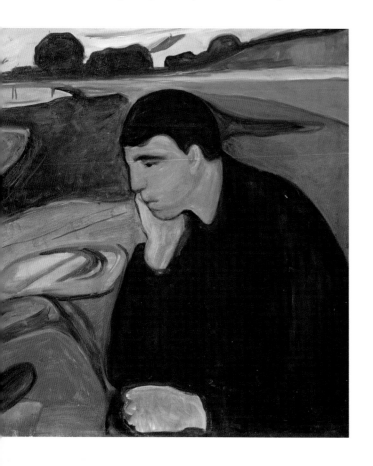

Bohemian Life

During the 1880s, Munch was a member of the Kristiania Bohème, a group of forward-thinking artists and writers, although he was not in the inner circle of the group. Nonetheless, their ideas had a major influence on Munch personally and Norway culturally. During their heyday in the 1880s, when they espoused the expansion of human rights and greater personal freedom, Norwegian artists moved to Munich and then to Paris, where traditional values were under scrutiny. Then they returned to insular Norway and promulgated the ideas of free love and severing ties with their own families. Munch observed them, painted portraits of their members like his friend Hans Jaeger (1854–1910), and formulated his own self-image as an artist dedicated to portraying 'the modern life of the soul'. Jaeger wrote an autobiographical novel in 1885 called *From the Christiania Bohemians* that was judged as if it were pure pornography. Copies were confiscated and Jaeger was incarcerated for two months; Munch gave him a painting of a woman in love that he hung in his cell. However Munch did not abide by all the group's precepts. For one thing, he remained close to his family in his own unconventional way all his life; if not in person, then through telephone calls and a steady stream of letters.

Bohemian Christian Krohg was a keen defender of Munch, calling him a 'a representative of the third generation'. He also commented favourably on Munch's painting *Melancholy*, 1894–95 (*see* page 63), saying it 'almost threateningly presages a new form of artistic vision'. Although Munch and Krohg would have their differences in coming years, Krohg remained an almost envious defender of Munch's art.

Parisian Life

In 1889, Munch moved to Paris and found a cheap room in the Hotel du Champagne, which he shared with two fellow Norwegians. From 8 a.m. to 12 noon, he studied art with Leon Bonnat (1833–1922), a pillar of the conservative art establishment, who taught Scandinavian and Japanese artists. While a harpist played music, nude female models posed for the male artists, who were instructed in the afternoons to copy things they found in museums and galleries. Bonnat also led the students on tours of his own substantial art

collection, including works by Rubens (1577–1640), Caravaggio (1571–1610), Titian (*c.* 1488–1576), Raphael (1483–1520), Watteau (1684–1721), Pissarro and Monet.

When Bonnat, a stickler for technique, deemed Munch's anatomical drawings good enough, he was permitted to work in the painting studio. It was there that a disagreement about colour spelled the end of any formal art instruction for the rest of Munch's life. In Bonnat's view, a brick wall in Munch's painting should have been pink, but Munch saw it as green and would not be swayed. So he packed his things and left, never to return. For a time afterwards, his friends shunned him and his only companions were waitresses and maids.

Munch developed a friendship with the Danish symbolist poet Emmanuel Goldstein. They would drink absinthe together and commiserate, followed by drunken trips to brothels, a habit that continued for several months. Munch wrote of the effect of absinthe: 'All sensations are perceived by all senses at once. My own impression is that I am breathing sounds and hearing colours, that scents produce a sensation of lightness or of weight, roughness or smoothness, as if I were touching them with my fingers.'

The Colours of Emotion

Speaking for himself and other artists, though he was alone among his countrymen in pursuing this agenda, Munch had a mission in mind: 'We want more than a mere photograph of nature. We do not want to paint pretty pictures to be hung on drawing-room walls. We want to create, or at least lay the foundations of, an art that gives something to humanity. An art that arrests and engages, an art created of one's innermost heart.'

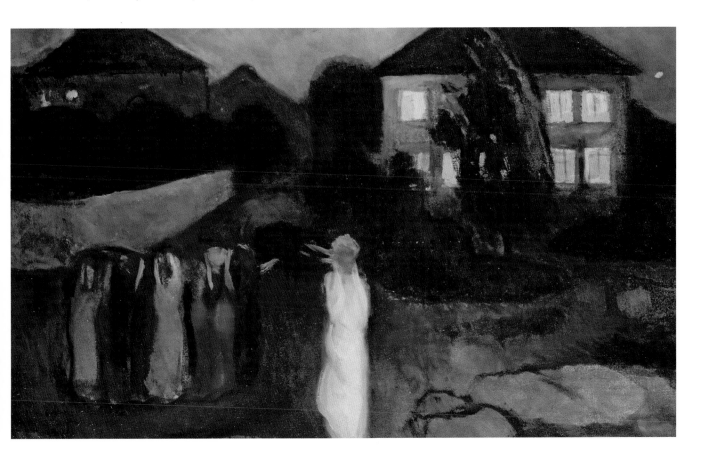

Munch saw the artist as more than an objective and keen observer of life and wanted to shun the conventional with this self-directive: 'We should no longer paint interiors with people reading and women knitting, they should be people who live, breathe, feel, suffer and love.'

According to biographer Sue Prideaux, Munch combined scientific colour theory with emotional theory, believing that the effects of colours on the optic nerve when in juxtaposition could leave a person feeling angry or calm. Some people understood his theories, one being Sigbjørn Obstfelder (1866–1900), who wrote in 1893: '… Munch writes poetry with colour. He has taught himself to see the full potential of colour in art…. His use of colour is above all lyrical. He feels colours and he reveals his feeling through colours; he does not see them in isolation. He does not just see yellow, red and blue and violet; he sees sorrow and screaming and melancholy and decay.'

1889: A Big Year

It was a time of inspiration and tragedy for Munch, who embarked on a project of prose writing. Ten of his paintings were shown at the Autumn Exhibition in Christiania, while five paintings, including the first version of *The Day After* (*see* page 60 for the 1894–95 version), were destroyed in a fire.

Munch had two epiphanies that year that became known as the 'Saint-Cloud Manifesto'. The first revelation occurred while taking a walk on a hill at Saint-Cloud during the transition from winter to spring. He heard a cock crow, he smelled a bonfire of burning leaves, and noticed new shoots of greenery pushing up through the earth and concluded that nothing ceases to exist, writing: 'I felt it as a sensual delight that I should become one with – become this earth which is forever radiated by the sun in a constant ferment and which lives – lives – and which will grow plants from my decaying body – trees and flowers – and the sun will warm them and I will exist in them – and nothing will perish – and that is eternity.' The second vision of the manifesto occurred when Munch, while watching a woman perform on a tightrope, realized that his life and art would forever be intertwined. The principles of this manifesto guided his career from that point onwards.

When his father died in November, after a stroke, leaving no money or pension for the family, Munch was prone to suicidal thoughts because he was haunted by all the deaths in his family, including those of his mother, sister and grandfather. He felt the black cloud of a hereditary curse. He wrote of his own lack of vitality: '… my daily walk round the castle becomes shorter and shorter, it tires me more and more to take walks. The fire in the fireplace is my only friend – the time I spent sitting in front of the fireplace gets longer and longer … at its worst I lean my head against the fireplace overwhelmed by the sudden urge – kill yourself and then it's all over. Why live?'

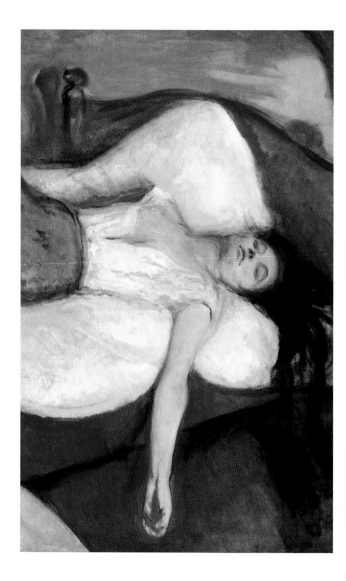

But the loss of his father also caused Munch to define his role as an artist: 'I paint not what I see, but what I saw.' By this statement, he meant his perceptions of a place or person were coloured by memory, contemplation and emotion rather than an exact depiction. The prism of experience and deep thought would flavour everything he did in a new way of approaching art.

Åsgardstrand

It was also in 1889 that Munch first visited Åsgardstrand, with its undulating coastline and soft midsummer nights serving as the inspiration and backdrop for many works in coming years.

On visiting Åsgardstrand, a small Norwegian fishing village, for the first time in 1889, Munch bought a house and enjoyed many summers there. He wrote about the place in romantic terms: 'Have you walked along that shoreline and listened to the sea? Have you ever noticed how the evening light dissolves into night? I know of no place on earth that has such beautiful lingering twilight.' Åsgardstrand also was a spur to his imagination, as he expressed to Rolf E. Stenersen (1899–1978): 'I get such a strong urge to paint when I am walking in Åsgardstrand.'

Berlin, 1892: A Critical Reception

In 1892, Munch had his first solo exhibition in Berlin. Invited by the artists' group Verein Berliner Künstler (the Association of Berlin Artists) – who were unanimous in issuing their approval that he showed what was promoted as 'Ibsenesque mood painting' – he was the first artist to have a one-man show in the group's 50-year existence. However, Munch had to develop a thick skin in response to the critical outrage his paintings aroused; and the show closed within one week.

German critic Adolf Rosenberg (1893–1946) wrote disparagingly about Munch's technique: 'These portraits are so sloppily daubed that at times it is difficult to identify themselves as human figures. There is nothing more to be said about Munch's picture, since they have no connection whatsoever with Art.' The *Frankfurter Zeitung* called Munch 'a poisoner of art ... An Impressionist, and a mad one at that, has broken into our herd of fine, solidly bourgeoisie. An absolutely demented character.'

Kaiser Wilhelm II (1859–1941) convened a meeting of the Verein on 11 November 1892, six days after its opening, and by a vote of 120 to 105 it was agreed to close the show amid screaming and fighting among the artists. Younger artists in the group broke away, because of the shabby treatment of Munch as an invited guest, and formed the Free Association of Berlin Artists, also known as the Berlin Secession.

But the press attention led to notoriety, and Munch began to exhibit and sell more of his paintings in Germany than he did in Norway, eventually being called 'the most famous artist in the whole of the German empire'. The Swedish critic Ola Hansson (1860–1925) was among many critics who likened Munch's process to literature rather than painting, and saw within his art the union of visual expression and psychology – a new and daring combination at a time when Norway and the rest of Europe were in the grip of new ideas from science and psychology.

'The Frieze of Life'

Munch credited the inspiration for 'The Frieze of Life' series (subtitled 'A Poem About Life, Love and Death') – on which he spent over 30 years working and reconfiguring for various exhibitions in and outside Norway – to talks and ideas generated by his discussions with bohemian friends and walks on long summer nights. In 1890, he wrote: 'I painted echoes of my childhood in the blurred colours of that time. By painting the confused colours, lines and shapes that I had seen in a moment of emotion, I hoped to recreate the vibrant atmosphere like a photograph. This is how the pictures of my frieze of life were born.' Munch used colours symbolically, with white representing innocence, red love and passion, and black grief and the solemnity of life. He once wrote, 'I consider the painting series to be one of my most important works, if not the most important….'

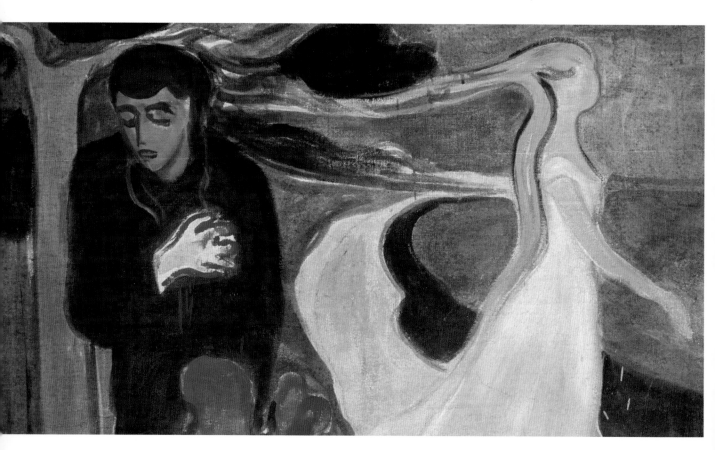

Each time this grouping of paintings was shown, the number of paintings changed, ranging from six at the least to 22 at the most. The sequence in which they were shown and how they were mounted varied as well. There were up to a dozen groupings for public perusal between 1893 and 1918. Writing in *Edvard Munch* (Rizzoli, 2013), Mai Britt Guleng analysed why the 'Frieze' attracted so much attention and speculation: 'Munch's pictures played upon the familiar, yet conveyed the new and it is precisely for this reason the series elicited questions and wonder. The picture series imply more than they explain, awaken curiosity rather than satisfy. In other words, the narrative is hidden in the individual viewer.'

It was Munch's intention to find a financial partner to subsidize a permanent home for 'The Frieze of Life' series. In 1925, he began a new series and new versions of earlier works such as *Ashes* (for the 1894 version, *see* page 59) and *The Dance of Life* (for the 1899–1900 version, *see* page 76).

'The Frieze of Life': Love's Awakening

First shown in an 1893 exhibition in Berlin, there were six paintings on love in the show, including *Vampire* (for the 1895 version, *see* page 64). Munch painted several versions, changing various details, but the essence remained the same – a woman's head is bent over a man's neck in an embrace. His head is bowed. It is about lust, desire, the envelopment of one person in the arms of another, and the submission necessary for the consummation of the erotic act. The Berlin exhibition was a success, leading to new and productive relationships with supporters and patrons. Munch was jubilant, writing to his Aunt Karen, 'New life, new hope!' It was a signal event in his life.

Other works on view were *Woman in Three Stages (Sphinx)* (*see* page 54), with women shown at three stages of life, from youth to old age. Munch described the figures as 'the Norns', in reference to the trio of goddesses of fate from Nordic mythology. *Ashes*, which was first an oil painting and then a lithograph, was also part of the exhibition. Munch wrote in his diary that the painting was about regretting committing adultery in the woods. *Jealousy* (*see* page 67) referred to the artist's affair with the wife of the male subject in the foreground, his friend

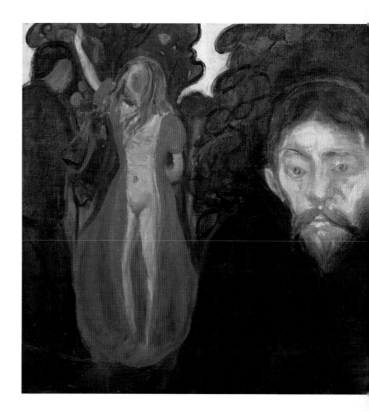

Stanislaw Przybyszewski (1868–1927). Munch believed that jealousy was an essential component of love. Grouping them together had a purpose, Munch wrote in a letter to Danish painter Johan Rohde in 1893: 'These paintings are rather hard to understand, but I think it will be easier if they are seen in context – they deal with love and death.'

The paintings about love were shown in Stockholm in 1894, in Christiania in 1895, and in Paris two years later. From 1895 to 1897, Munch spent time translating his painted imagery into woodcuts and lithographs. When paintings in the series were sold, he merely painted new versions of them. The motifs of love were set outdoors, harkening back to literary and visual art traditions dating to antiquity. He wrote of them: 'The pictures showing a beach and some trees, in which the same colours keep returning, receive their prevailing tone from the summer night. The trees and the sea provide vertical and horizontal lines which are repeated in all the pictures; the beach and the human figures give the note of luxuriantly pulsing life and the strong colours bring all the pictures into key with each other.'

In 1902, Munch was invited by the renowned German artist Max Liebermann (1847–1935) to show 'The Frieze of Life' at Berlin's Secession Gallery, where the paintings were displayed in systematic sequence for the first time. All 22 paintings were shown on four walls, grouped under the titles: 'Love's Awakening', 'Love Blossoms and Dies', 'Fear of Life' and 'Death'. The show then travelled in 1903 to Leipzig, before showings in Copenhagen, Christiania and Prague. Each exhibition featured different works with no fixed sequence. Munch was known for re-working certain paintings and giving them new titles. The titles did not matter much to him – if they were re-named by a gallery director or museum owner, he would approve.

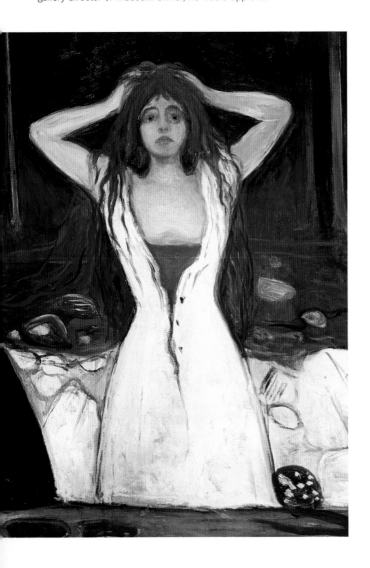

'The Frieze of Life': Love Blossoms and Dies

The expression of erotic energy led to *Ashes*, with a log in the foreground symbolic of the wood turned into something else after passion is spent. A man despairs in the corner, holding his head, while the woman stands straight, representing a different mood, perhaps relief or exhaustion. *Woman in Three Stages (Sphinx)*, from youth to old age, was the centrepiece of the section 'Love Blossoms and Dies'. The unpartnered women on the dance floor in *The Dance of Life*, 1899–1900 (*see* page 76) watching other couples enjoying themselves, create lonely figures plagued by possessiveness and jealousy, aspects of love in its inevitable souring.

'The Frieze of Life': Fear of Life

While scenes of lovers were often set outdoors, paintings about the fear of life were set on city streets, roads and bridges, or near crowds. Social anxiety and loneliness are apparent in *Evening on Karl Johan Street*, 1892 (*see* page 49). Persecution is evident in *Golgotha*, 1900 (*see* page 79) with the artist portraying his crucifixion by the critics. The sinister mood of *Red Virginia Creeper*, 1898 (*see* page 74), featuring a man with haunted eyes, is about a guilty conscience.

Anxiety, 1894 (*see* page 57) is very similar to *The Scream*, with Munch attempting to capture a feeling he had about a sunset. Perhaps inspired by a road or bridge in *Crime and Punishment* (1866) by Fyodor Dostoevsky (1821–81), which Munch read at the age of 22, *The Scream* had its basis in a certain place and moment. Writing in his memoir, he described the genesis for his most famous painting. He was walking on a hilly path near Christiania with two friends while in a state of inner agitation: 'It was a time when life had ripped my soul open.' The sun was setting, which he likened to 'a flaming sword of blood' and colouring the hills a deep blue. 'Witnessing these changes in nature proved overwhelming … the lines and colours vibrated with motion – these oscillations of life brought not only my eye into oscillations, it brought also my ears into oscillations – so I actually heard a scream – I painted the picture *Scream* then.'

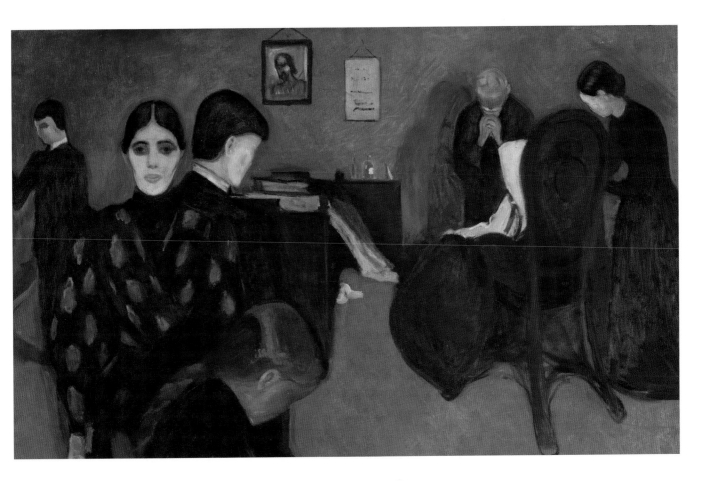

'The Frieze of Life': Death

An essential part of 'The Frieze of Life' series was the paintings about death, including *The Dead Mother and the Child*, 1897–99 (*see* page 72), which was a pen drawing before it was an oil painting, *Death in the Sickroom*, 1893 (*see* page 50) and *The Death Bed*, 1895 (*see* page 66). Five adults are powerless in the presence of death in the autobiographical *The Dead Mother and the Child*, with the artist's sister Sophie reacting with her hands over her ears, as if death were a piercing scream. The helplessness leaves the adults limp, grieving and sadly disconnected as they try to comprehend the enormous void of the loss. The forbearance of a suffering child and the grief of an adult caregiver in *The Sick Child* (*see* page 48) motivated the artist to create different versions in different media over the years, which he called 'experimental copies'. As defined by writer Emile Zola (1840–1902),

naturalism in art was 'a corner of nature seen through a temperament'. Munch's visions were marinated in personal experience and differed from other sickness and deathbed paintings by his contemporaries that were in vogue at the time. They were memorials to his experience and the pain that death inflicts on those left behind to cope.

Gaining Recognition

The new century brought new acclaim. In 1906, Munch designed the sets for Ibsen's (1828–1906) *Ghosts* and *Hedda Gabler* in Berlin. In 1909, 24 Norwegian artists competed to paint murals at the Festival Hall (Aula) at Oslo University in Christiania. Munch won the competition and began working on a series of three paintings, finishing seven years later. These three paintings were *The Sun*, 1909, *History*, 1911–16 and *Alma Mater*, 1911–16, unified by the shorelines of Kragerø and Hvitsen.

In January 1929, Munch was invited to participate in a group show in Düsseldorf, a retrospective of Expressionism presented by the Sonderbund group. It came to be known as the first international exhibition of modern art, including the work of 169 artists. Munch was allocated the largest room of all, and showed 32 paintings. He was praised as the spiritual leader of the new avant-garde, and this led to an exhibition of his work at the Armory Show in New York, and his first and only visit to England in 1913 for a showing of Norwegian modern art at Brighton Museum. In the same year, he had a show with Picasso at the Sonderbund exhibition in Cologne. There were also one-man shows in many cities including Prague, Düsseldorf, Vienna, Copenhagen, Berlin, Budapest and Rome. Furthermore, Munch was in demand for commissioned portraits of rich patrons and their children.

In 1922, Munch created a 12-painting frieze for the workers' canteen in the Freia Chocolate Factory in Oslo. In 1827, there were major retrospectives in Berlin and Oslo. In 1928, he designed murals for the Oslo Town Hall.

Tulla Larsen

Munch's conflicted feelings about women came to full and ugly fruition in his relationship with Mathilde Tulla Larsen. At the time of their meeting in 1898, she was tall and slim at age 29 with an hourglass figure and red hair. She was the daughter of a leading wine merchant in Christiania and a woman of means, who lived by herself and dabbled in art. In the first couple of years of the 1900s, Munch and Tulla travelled to Berlin and Florence. She was very fond of him and marriage was discussed, but Munch always felt that wedlock and children would interfere with his calling as an artist. He felt increasingly unnerved in her presence. He painted the two of them like Adam and Eve in *Metabolism*, 1898–99 (*see* page 73), and she also appears expressing jealousy in *The Dance of Life*.

When Munch fell upon financial hard times, due to an unwillingness to part with his paintings and having no other means of consistent support, Tulla offered him money and he took it with the intent of repayment. She became obsessed with him and hoped to single-handedly support him. He fled to different cities but she deluged him with calls and letters, even waging a campaign in which she enlisted the help of her mother and sisters to win his undying affection. The stress of the situation made Munch drink to the point of distraction, landing him in a sanatorium.

In a letter to Tulla, Munch wrote a very demeaning marriage proposal setting forth untenable terms to which she clung with abnormal ferocity, despite its lack of loving kindness. He was in a torment of regret, guilt and doubt when he wrote of her: 'I saw her as the black angel of my life … and my thoughts see-sawed backwards and forwards, between self-recrimination and despairing hatred. Had I led her into the fire of hell?'

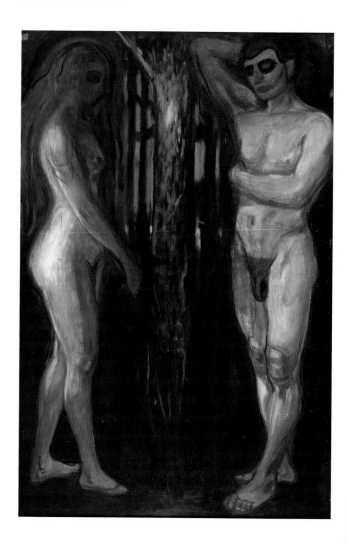

Munch recuperated in a spa hotel before heading back to Christiania, where he found a benefactor in Olaf Schout, who gave him a loan. But Tulla would not let go or give up. She brought a lawsuit against him, which shocked him and burdened him with years of loans. He was forced to pawn his paintings to repay debts, and to mortgage the deeds to his house.

They met one last time in Åsgardstrand in 1902, when he was reluctantly convinced to visit Tulla who was said to be killing herself in despair over their affair, with the ingestion of morphine. A revolver was discharged at their meeting, severing the top two joints of the middle finger of his left hand. The injury pained him even into old age, whenever he held a palette. Even worse were the mental scars of the injury and disfigurement.

Plagued by feelings of persecution in Norway, Munch returned to his nomadic existence on the Continent, becoming involved with the English violinist Eva Mudocci, of whom he created lithographs. But nothing else in his romantic life would ever be as tumultuous as the relationship with Tulla Larsen.

Experimenting with Techniques

Munch was among the first artists to present oil sketches as finished work. He learned about woodcuts, etching and lithography by watching professionals, moving his studio close to theirs and developing his own techniques. His woodcuts and coloured lithographs were first printed in 1896. He turned to printmaking in part for the money, because he had a difficult time parting with his paintings when they were sold, and in some cases wanted to rescind these transactions and have the works back in his possession. But there was another reason he moved beyond painting to other methods of expression: 'My intention in working with graphics was to bring my art into many homes.' To that end, he had an idea of transforming the entire 'Frieze of Life' series into a graphic sequence called 'The Mirror'. He started on the project, exhibited parts of it, and toyed with the idea for decades, but it never came to fruition.

In 1896–97, Munch worked with the famous printer Auguste Clot (1858–1936), creating different colour combinations of *The Sick Child*. He discovered the power of changing the image in two different

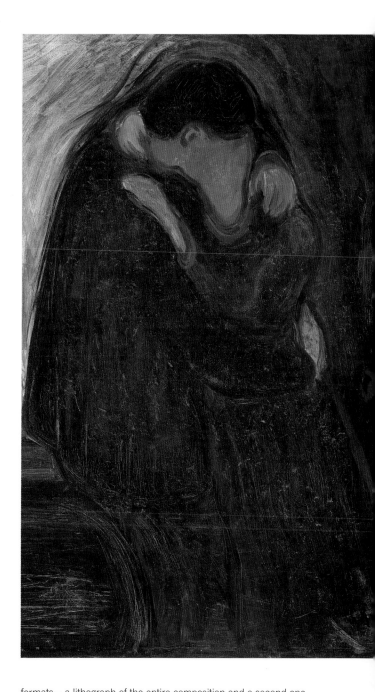

formats – a lithograph of the entire composition and a second one, like a photographic close-up of the girl with her head on the pillow. He hardly ever numbered his prints in editions and wanted to keep his own lithographic stones to make future reprints. However, in this case he paid Clot to keep them.

In 1896, Munch started making woodcuts, learning to prepare the block himself and printing his own trial proofs. Woodcuts were much less expensive than lithography. In the following year, he developed a unique jigsaw puzzle-cut, using a fretsaw to cut the wooden blocks into pieces, inking them individually, and then putting them back together for the image and printing as a single block. He was also able to incorporate the wood grain into the design of some pieces, as in his woodcut of *The Kiss*, 1897–1902.

Although Munch called his paintings his children and could not bear to part with them, even to his own financial detriment, he did not treat them well. In an act that others found odd and disconcerting, he would leave his paintings outside in the elements, as a kind of survival test in sun, rain and other weather events. What he called 'the horse cure' was not merely a capricious act. The artist was seeking a dry, matte, fresco-like surface on the paintings, as well as an accelerated way to

give them an aged appearance. He also abhorred the varnish that was put on paintings to finish them, as he felt this coating did not allow his paintings to breathe. When the Nasjonalgalleriet in Norway acquired several of his paintings and varnished them, Munch was upset and felt that their depth had been destroyed.

He was fascinated by the application of thin, almost transparent, layers of paint to give his scenes a very light feeling. The size and vigour of his brushstrokes was meant to convey mood and atmosphere.

'The Reinhardt Frieze'

The Berlin theatre impresario Max Reinhardt (1873–1943), artistic director of the Deutsches Theatre, presented Ibsen's play *Ghosts* in 1906, with set design by Munch. Then he commissioned the artist to design a frieze for the small oval hall on the first floor of the Berlin

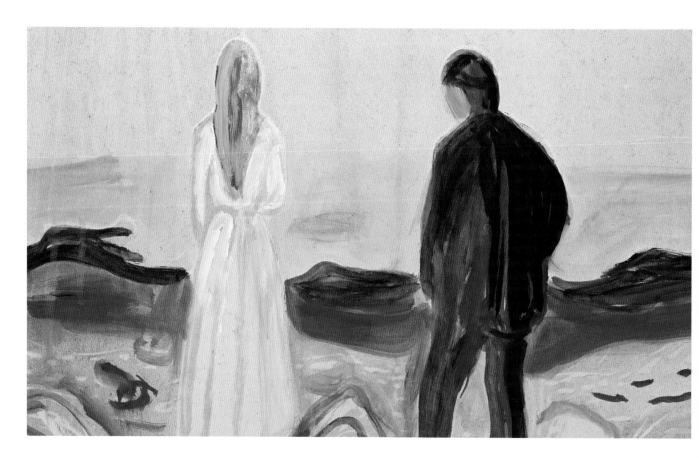

amber Theatre. It involved 12 paintings, completed in late 1907.
ey were displayed on four walls with motifs of men and women
m a summer night on the beach outside Munch's house in
gardstrand, and were hung high up over the doors and between
e windows. To make the paintings easier to see, the artist was
reful to delineate people and landscapes with clear brushstrokes.
e commission involved a change in technique and Munch used
mpera on unprimed canvas, with the result that the paint conveyed
e intense light of a midsummer night in Norway. The frieze included
e paintings *Åsgardstrand*, with its prominent column of yellow
oonlight on water, *The Dance of Life*, *The Lonely Ones* and *Couple
* the Shore* with an embracing duo.

unch wrote of the series' consistent element: 'Through the whole
ries runs the undulating line of the seashore. Beyond that line is
e ever-moving sea, while beneath the trees is life in all its fullness,
variety, its joys and sufferings.' Munch was glad to finish the frieze
d wrote in a letter to his friend, Jens Thiis (1870–1942), in 1907
at its creation was 'real torture … payment is quite out of proportion
the effort involved'. Response to the frieze was poor, as it was
garded as a pale decorative version of 'The Frieze of Life'. In 1912,
en the space was restyled, the paintings were sold. In 1966, the
rlin National Gallery showed eight of the paintings from the
einhardt Frieze'.

ocial Reform for Women

unch was clearly influenced by social progress in Norway. An entry
his journal in February 1929 reads: 'I have lived in the transition
ward women's emancipation.'

1913, the year in which Munch turned 50, women in Norway won
e right to vote. This was the culmination of a movement from 1875
1900, when social forces within the country were moving toward
odernity. For example, parliamentarism was established, as was the
orwegian Association for Women's Rights. The issue of women's
hts was supported by the cultural elite of Norway and dramatized
the play *A Doll's House* in 1879 by Munch's Norwegian friend
enrik Ibsen.

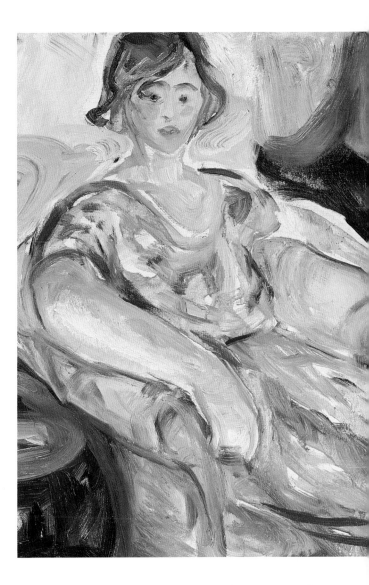

Certainly one of the most blatant paintings about female-male equality
in that period by any European artist was Munch's *The Day After* (*see*
page 60). A woman lies on a bed in the aftermath of a night of
euphoria achieved through drink or sex or both. Just like a man who
has experienced a night of self-indulgence, the woman needs sleep in
order to recover. Created during a time of temperance, when social
leaders worried about widespread drunkenness and women were
always expected to be sober, this painting was justly controversial.
But there is no doubt that Munch contributed to the advancement of
women's fight for progress in Norway.

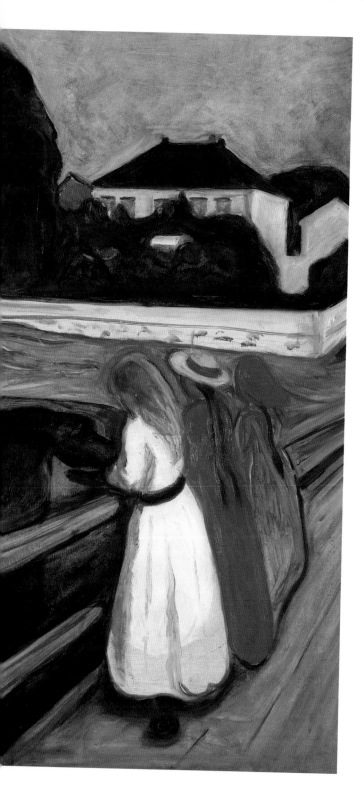

Munch's Views on Women

Although some Munch scholars have branded him a misogynist, it is a short-sighted opinion. His views on women were complicated by contrary feelings, depending on the person and situation. He felt love, understanding, repulsion and fear for them, all marinated in his own neuroses. He was pained when a lover got too close or demanded too much of him, yet women sought his company and he enjoyed theirs for most of his life. The pejorative term, 'misogynist', arose from Rolf E Stenersen's monograph *Edvard Munch – Close-Up of a Genius* (1969) Stenersen developed the idea out of the power that the artist exerted over women but, by that theory, every male artist who used female models would also be called a misogynist. The scholar also noted that Munch associated women with death, which is hardly positive.

Munch's positive attitude towards women was fostered in a female-centric home during his formative years. After his mother's death, his Aunt Karen moved in to assume domestic duties and the raising of three girls and two boys. Edvard had an unusually strong bond with his sister Sophie, just one year older, until her untimely death at the age of 15. He maintained a close relationship with his aunt and the rest of his family through letters, telephone calls and gifts for the rest of his life.

Yet this heterosexual man who took many lovers also made a personal vow to avoid the ultimate commitment of marriage because he felt it would be a betrayal of his life's purpose. He shared the same philosophy as Friedrich Nietzsche (1844–1900) that women were temptresses, an opinion visible in paintings like *Girl under Apple Tree*, 1904 (*see* page 98), among others. The artist wrote about his intention: 'I have always put my art before everything else. Often I felt that women would stand in the way of my art. I decided at an early age never to marry.'

Depicting Women

The female at all ages and stages of life is present in many Munch paintings. He admired girls at the height of their sweetness as children, as in *Girls on the Pier*, *c.* 1901 (*see* page 85), among other paintings. These straightforward portrayals avoid any shred of sentimentality. A misogynist could not have created *Puberty*, 1894 (*see* page 58), at

the age of 30. This empathetic painting conveys such tenderness in the way the nude young lady sits on the edge of the bed, with her arms covering her private parts. It is the moment of realizing a transition from girlhood to adolescence, signalled by several drops of menstrual blood on the sheet. There is no sense of impropriety or rude intrusion conveyed. Instead, the painting has an almost photographic ability to capture the situation objectively. There is heroism on two fronts in *The Sick Child* as the suffering girl exudes a stoicism that is transcendent, while a grieving woman weeps at her side.

Women came in all temperaments and moods to Munch and, through him, to his art. Ingeborg W. Owesen, writing in *Edvard Munch: 1863–1944* (published in 2013), assesses Munch and women: 'Love is one of Edvard Munch's major themes. As a heterosexual man, women were objects of his love and desire: women are the cause of both grief and joy, frustration and happiness. Women therefore became the bearers and the symbol of both negative and positive romantic experiences.'

The fact that the main figure in *The Scream* is androgynous gives rise to a theory that perhaps it is a woman whose cry is a protest about the narrow, even suffocating role of woman as wife and mother confined to the home. The malleability of interpretations that one can draw from the painting exemplifies how relevant it remains more than a century later. Even in erotically charged paintings like *Vampire in the Forest*, 1916–18 (*see* page 118), with a woman as a sort of hungry sexual predator locking a man in her clutches, there is no recrimination or horror at her power over him. If anything, Munch can be said to convey a sense of awe that this member of the so-called weaker sex can command such

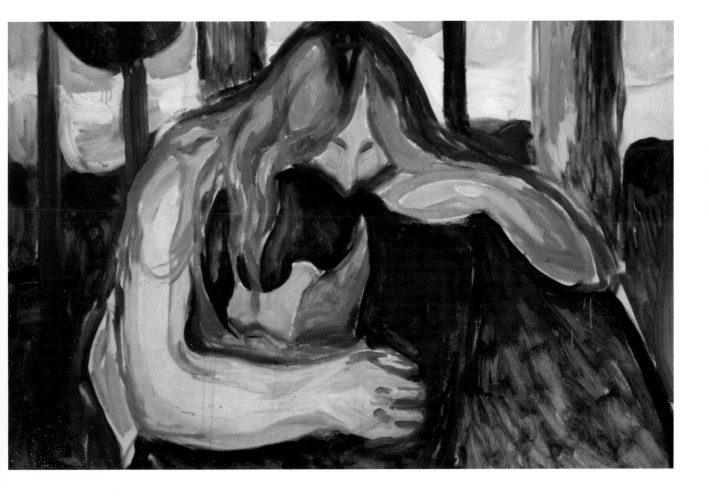

subservience from a physically stronger man. When the Nazis called the painting 'morally degenerate', Munch had an amusing and pithy response, insisting it was nothing more than 'just a woman kissing a man on the neck'. So Munch's views about women were fuelled by neurosis, experience and true regard, and he glorified them in his remarkable oeuvre at all stages of his life.

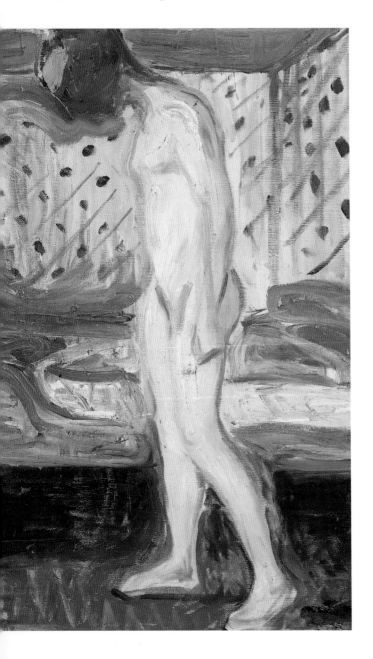

Breakdown

Afflicted with jittery nerves and unaccountable bouts of anger, which heavy consumption of alcohol failed to blunt, Munch found himself hearing voices, seeing visions, becoming increasingly paranoid, and experiencing small turns of paralysis in his limbs. Friends Jappe Nilssen (1870–1931) and Harald Nørregard (1864–1938) tried to convince him that his feelings of persecution by others were all in his head, but to no avail. They did get him an appointment with the psychotherapist Einar Brünning, but Munch found him 'too serious' and never returned to his office.

Another friend was more successful in getting Munch to a Copenhagen nerve clinic, where he was treated by the able Dr Daniel Jacobsen, who defined his condition as dementia paralytic, a consequence of alcohol poisoning. The treatment sounds like something one would find at a luxury hotel or spa today. A holistic approach was taken at a secure nursing home with flirtatious nurses. It involved rest, good food, medicated baths, chest massages, sleep medicine and the gentle application of a weak electrical current – nothing like the electro-convulsive therapy used on some mentally ill patients today.

Munch's friends from Norway and Germany kept in touch with him, forming a bulwark against depression during his months at the clinic. While there, he won Norway's Order of St Olaf and felt a duty to return to his native country, eventually settling in Kragerø, a working community of fishermen and boat builders, rather than a summer vacation spot like Åsgardstrand. Munch knew what he needed to do to preserve his sanity – avoid alcohol, tobacco and poisonous women.

His delicate mental state and obsessive fears led to other visits to sanatoria in Switzerland and Norway, none of which were so debilitating to delay, halt or alter his reserves of creativity and inspiration. Munch remained prolific, he felt, because of his weaknesses and illnesses, the handmaidens throughout his life, more faithful than any lover or friend.

Solitude and Recovery

Though suffering from periods of presumed persecution, Munch took refuge in an estate at Ekely near Christiania after the First World War.

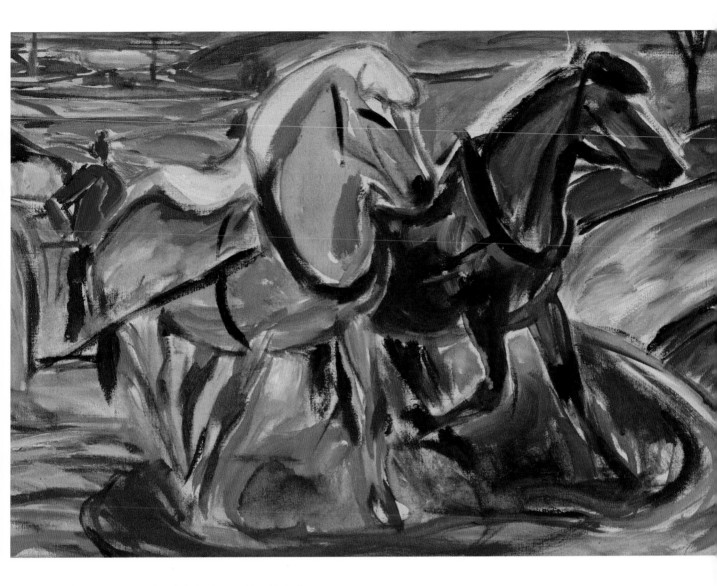

Its 11 acres were devoted to growing fruits and vegetables. He had dogs for company and a horse named Rousseau whom he used as a model for ploughing the fields as well as a series of large horse paintings. He also made paintings of anthropomorphic trees like ancient tree gods. Paintings like *The Man in the Cabbage Field*, 1916 with a farmer's arms full of produce, animals and fruit trees in the orchard were enormously popular. Nilssen wrote of them on exhibition: '… every single picture resonates like a hymn to nature, to the fertility of the earth, to animals and to humanity.' If the company of other humans could not heal or calm him, nature could and did.

Degenerate Art: Nazi Reaction in the Second World War

The seeds for condemnation of many European modern artists was set in 1928 with the distribution of a photographic book written by racial theorist Paul Schultze-Naumburg (1869–1949), which featured photos of people who were insane, diseased and deformed, interspersed with portraits by Munch, Paul Cezanne (1839–1906), Paul Gauguin (1848–1903), Henri Matisse (1869–1954), Piet Mondrian (1872–1944), Pablo Picasso (1881–1973) and Van Gogh. In 1933, Munch's art was

deemed degenerate, banned and confiscated based on its cosmopolitan nature. It was taken from public museums and even the homes of private collectors, some of whom were Jewish. Ironically, in 1932 Munch had been given the Goethe medal for Science and Art.

Hitler's right-hand henchman Joseph Goebbels (1897–1945), however, personally liked Expressionist art, but he did not tell Hitler that he had sent 70th birthday good wishes to Munch that read: 'I greet you as the greatest painter of the Germanic world.' So there could be no question about what the Hitler regime reviled in the way of visual art, an exhibition titled 'entartete Kunste' (Degenerate Art) opened in Munich in June 1937. Two million people saw it in a period of four months, before it toured Austria and German. Visitors were given instructions

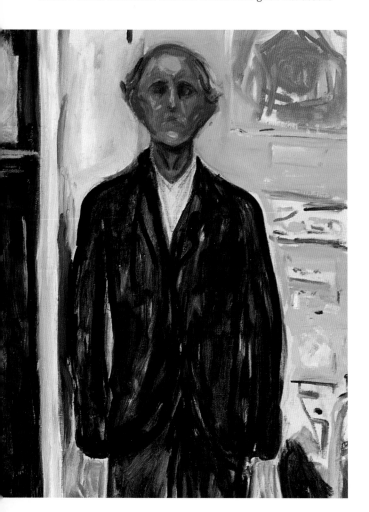

about the hatred they were to feel in the presence of the banned art: 'All around us you see the monstrous offspring of insanity, impudence, ineptitude and sheer degeneracy. What this exhibition offers inspires horror and disgusts us all.'

It was said that the paintings were put on a big bonfire in front of the Berlin fire department in 1939, though that fact is in dispute as there was money to be made from them; it is now thought that only the frames of the paintings were destroyed. In the same year, 14 Munch paintings were impounded in Germany and auctioned off there and in Switzerland. Many major works were saved, including *The Sick Child* and many self-portraits. The artist himself, having been thrown out of Germany, expressed ignorance about the whereabouts of his paintings. He did what he could from afar, sending money to persecuted German and Czech painters and funding a scholarship so an artist could leave Germany.

In April 1940, the Germans invaded Norway and Munch lived in fear that his own home would be raided and his artwork destroyed, but it never happened. In a pre-emptive move, philanthropist Thomas Olsen (1897–1969), who had saved some of Munch's paintings, hid them from the occupying German forces in a neighbour's hay barn, where they remained safe. What an irony that Munch, who had had success in Germany and lived there for periods, was presumed by some to be a Nazi sympathizer, which he most definitely was not.

Between Life and Death

The 1940s brought the Second World War and, for Munch, more works contemplating life and death. The war made it difficult to travel, as he had liked to do in years past. He settled in Ekely and sent his sister, Inger, potatoes from his thriving farm. He worked with a young female law student as his model and made a number of dour self-portraits, the most blunt being *Self-Portrait Between the Clock and the Bed*, 1940–43 (*see* page 125), which showed him squeezed by the tyranny of time's passage and his own dwindling hold on mortality. The bed beckons like a final resting place, as the artist stands surrounded by his paintings and a grandfather clock marking the inexorable march of minutes and hours.

Worried about the power of Hitler and fearing annihilation, Munch was agitated further by news of executions of priests and children at Akershus Fortress, where his doctor father had once worked. A bout of bronchitis sounded the artist's death knell, but not before he completed a new lithograph of his old bohemian friend Hans Jaeger, who had had such a profound influence on his life and career. Sadly and ironically, the Nazis participated in his funeral and burial.

Legacy

While another artist might have cursed the challenging life forces that shaped him, Munch seemed to feel grateful to have had them as major influences, stating: 'Without fear and illness, my life would have been a boat without a rudder.'

More than a century after its creation, *The Scream* – the artwork Munch is best known for – remains unchallenged as the premier pictorial depiction of modern man's angst. Copied, re-configured, co-opted and popularized for generations, the painting has a curiously contemporary, present-day resonance that defies explanation. It is dismissive and unfair to attribute its creation to the artist's considerable mental demons and neuroses. Munch felt that he had a mission to create art that moved viewers to a personal reaction of their own, something he accomplished in dozens of paintings and other artworks other than *The Scream*. For a full appreciation of his remarkable life's work, *The Scream* should be the gateway to a fuller understanding of his contributions to art and appreciation of the troubled, deeply feeling man who created them without shame and beyond worry for his own reputation.

As for the artists on whom he had an effect, one can look to German Expressionist painters Ernst Ludwig Kirchner (1880–1938), Wassily Kandinsky (1866–1944) and Max Beckmann (1884–1950), all of whom painted based on their individual psychology and use of intense colour and semi-abstraction. Even the art of Francis Bacon (1909–1992) owes a debt to Munch.

Writing about 'The Frieze of Life' in the same-titled book of 1994, Gerd Woll puts the intrigue of this group of paintings in perspective, in light of Munch's thoughts: 'He believed that the spirit of the artist lived on through

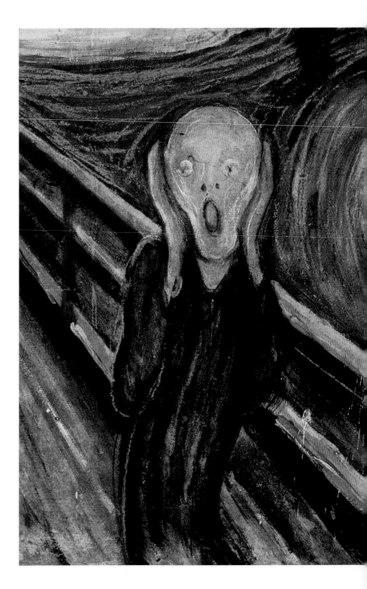

his work, and that even after his death the artist could help others gain greater insight into their own lives and problems – provided he was able to express in his pictures his own sufferings, ideas and feelings in a way that enable other people to understand and relive them.'

Art lovers and scholars can be grateful that Munch died leaving the art in his possession to the city of Oslo in Norway. A museum devoted to these works opened in Oslo in 1963, commemorating the centenary of Munch's birth, and is still open to this day.

Between Naturalism and Impressionism

In Munch's early years as an artist his works tended to veer between Naturalism and Impressionism, particularly influenced by his travels to Paris where he saw exhibitions featuring such artists as Manet and Pissarro.

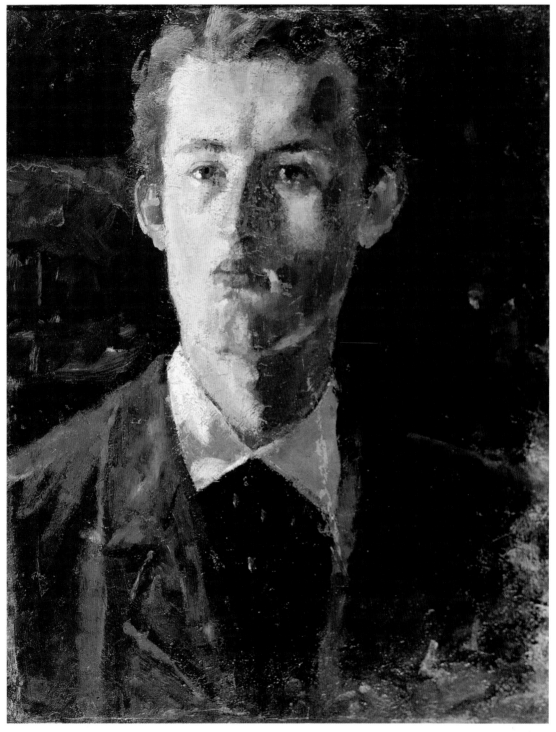

Self Portrait, 1882
Oil on canvas, 25.5 x 18.5 cm (10 x 7 in)
• Bymuseet, Oslo

The artist as a young man has a serious demeanour. Self-composure and arrogance are in the set of his jaw. Yet the portrait also conveys his sensitivity.

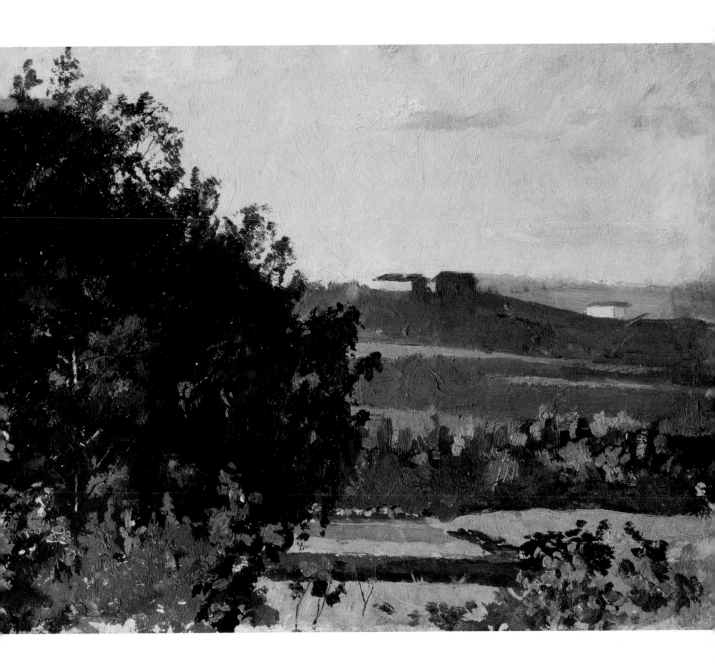

View of Grüners Garden, *c.* 1882–83
Oil on canvas, 21.6 x 28.9 cm (8 x 11 in)
• Private Collection

Many of Munch's earliest works were landscapes such as this one, depicting the surroundings of Oslo, then known as Christiana, where Munch had grown up. It shows his tendency towards naturalism early on.

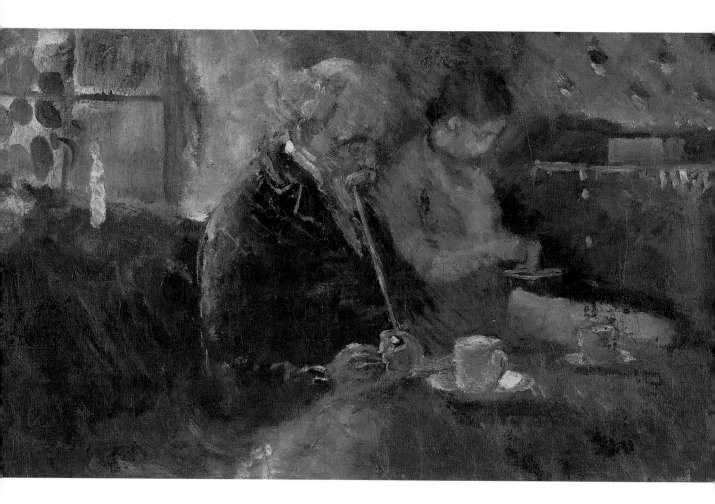

At the Coffee Table, 1883
Oil on canvas, 45.5 x 77.5 cm (18 x 31 in)
• Munch-museet, Oslo

With their heads bowed, this man and woman concentrate on different things, belying the intimacy suggested by their physical closeness. Peaceful domesticity is conveyed in a realistic fashion.

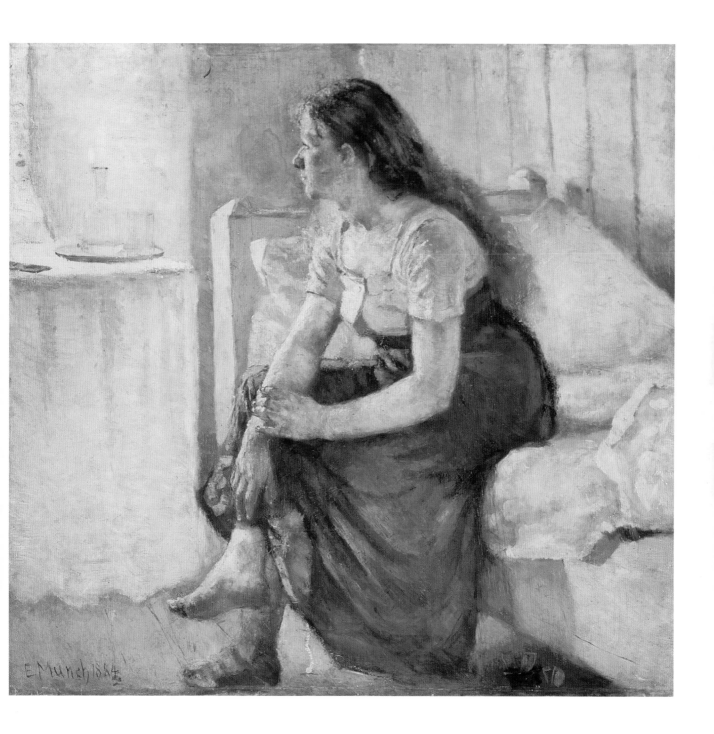

Morning, 1884
Oil on canvas, 96.5 x 103.5 cm (38 x 41 in)
• Rasmus Meyers Samlinger, Bergen

With her face turned towards the window and one shoe off, this pensive woman with undone hair cascading down her back is a portrait of repose. The artist realistically captures a quiet moment in her day.

**Aften (Evening Hour with the Artist's Sister Laura)
(The Yellow Hat), 1888**
Oil on canvas, 75 x 100.5 cm (30 x 40 in)
• Private Collection

Thoughtfully gazing out to sea, rather than at the people in the background,
this introspective portrait of repose sums up the quietness of rural life.

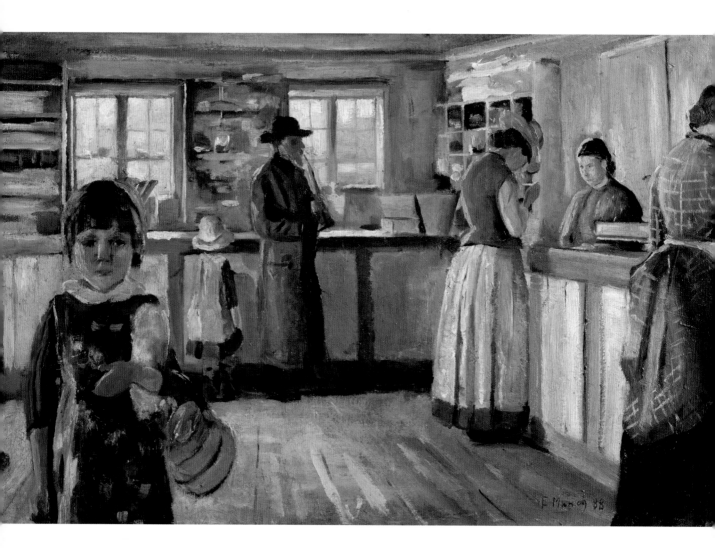

Vrengen Village Shop, 1888
Oil on canvas, 44.5 x 69 cm (18 x 27 in)
• Private Collection

The girl in the foreground, proud of her role as family errand runner, is the top of a triangle with the adult customers in this slice of rural commerce.

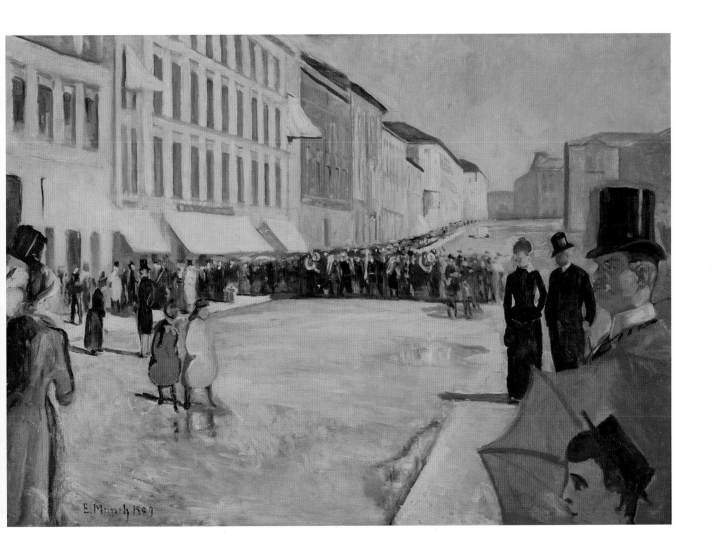

Military Band on Karl Johan Street, Oslo, 1889
Oil on canvas, 102 x 141.5 cm (40 x 56 in)
• Kommunes Kunstsamlinger, Oslo

Anticipation from the children in the street contrasts with the disconnection of the couple walking away from the musicians and a boy with a red umbrella. It is among the paintings that first brought attention to Munch.

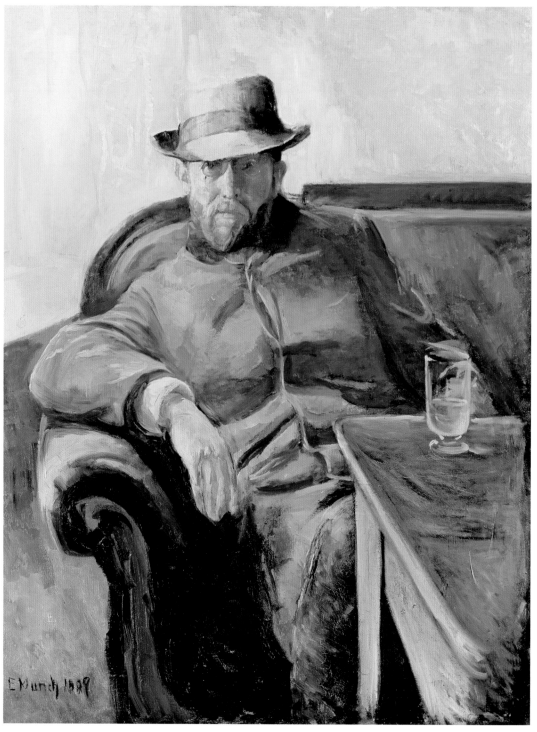

Portrait of Hans Jaeger, 1889
Oil on canvas, 109.5 x 84 cm (43 x 33 in)
• Nasjonalgalleriet, Oslo

Sitting in the Grand Hotel, site of late-night intellectual group discussions about expressing emotion in the arts, this writer, philosopher and friend of the artist appears relaxed, despite his buttoned-up overcoat. He has an air of utter self-confidence.

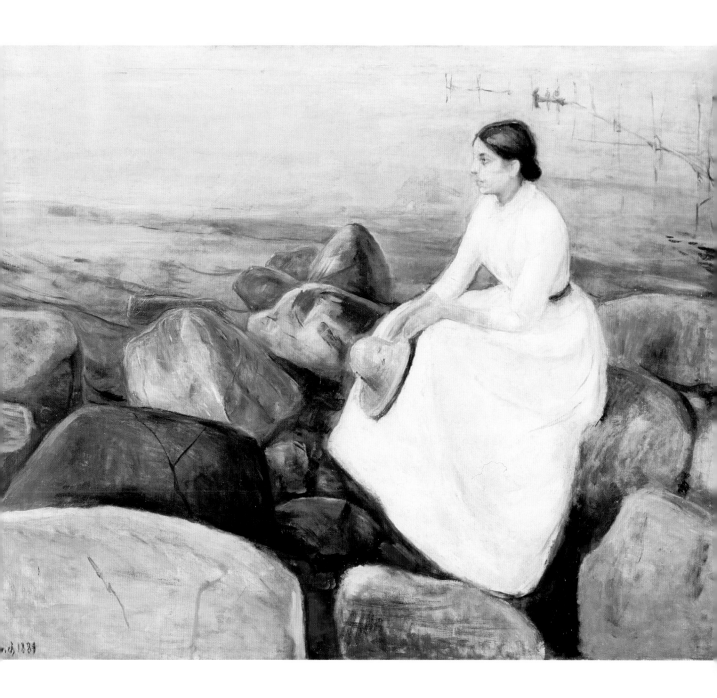

**Inger on the Beach, or Evening
(Summer Night at the Seashore), 1889**
Oil on canvas, 126.5 x 162 cm (49 x 63 in)
• Rasmus Meyers Samlinger, Bergen

The variegated colours of the hard rocks contrast with the virginal purity of the soft-looking pale woman in a white dress staring into the distance. She is the artist's sister, a paradigm of virtue.

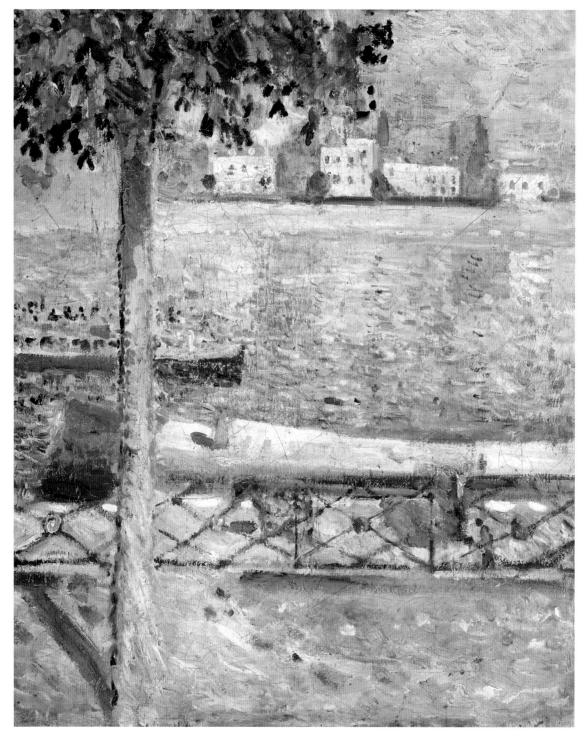

The Seine at Saint-Cloud, 1890
Oil on canvas, 46 x 38 cm (18 x 15 in)
• Munch-museet, Oslo

A pretty vista rendered using the Impressionist style to suggest the play of sunlight on water
against the shadows of the river's depths is energized by the presence of a boat with passengers.

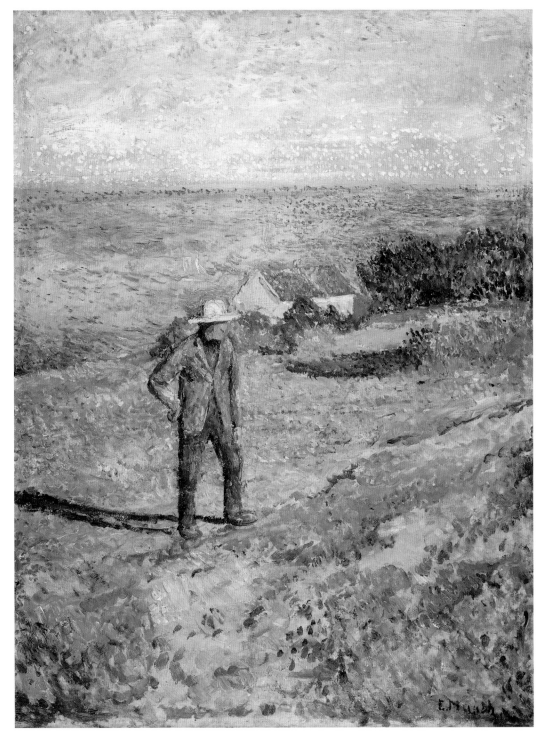

Summer in Åsgardstrand, c. 1890–92
Oil on canvas, 69.3 x 52 cm (27 x 20 in)
• Private Collection

Brief energetic brushstrokes convey the short grasses on the hill, while sky and sea suggest infinity with a sweeping hand. Munch first visited Åsgardstrand in 1899, and he was to revisit and paint it many times over the years.

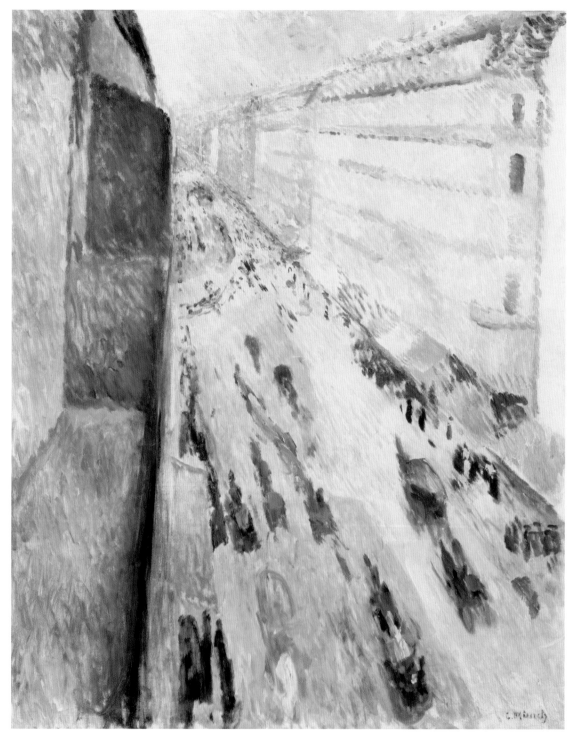

Rue de Rivoli, 1891
Oil on canvas, 81 x 65 cm (32 x 26 in)
• Fogg Art Museum, Harvard Art Museums, Cambridge

With a bird's eye view from an upper floor window or a balcony, the artist brings a fresh perspective to moving figures on the street below. Munch makes them a distorted and energetic blur from this dramatic angle.

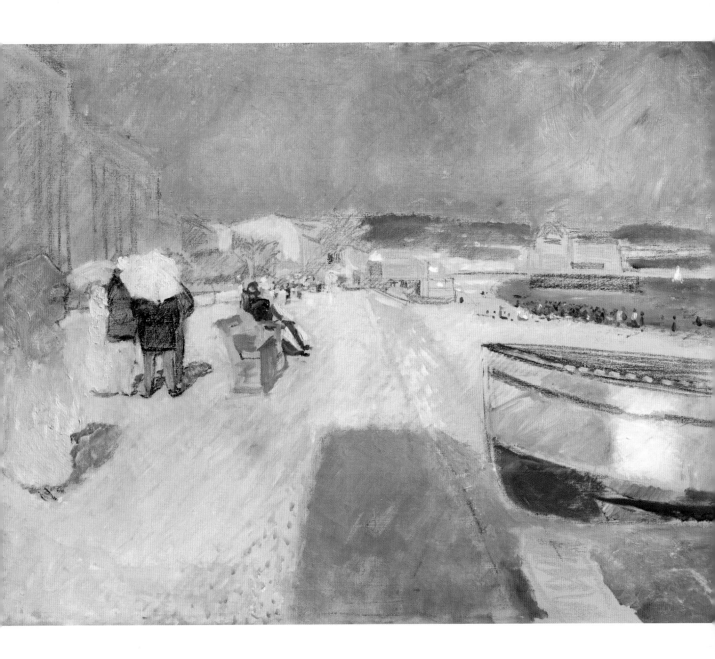

Promenade des Anglais, 1891
Oil and pastel on canvas, 55 x 74 cm (22 x 29 in)
• Private Collection

The rowboat in the foreground, the blue shadows, blue sea, sky and mountains make this a painting about a place and time; a day of leisure conveyed through colour and form.

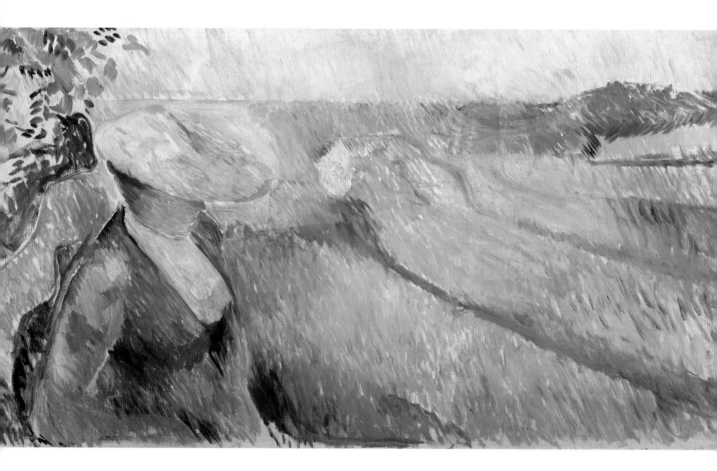

The Open Air, 1891
Oil on canvas, 65 x 54 cm (25 x 21 in)
• Munch-museet, Oslo

While the woman provides a central focus, she appears to be at odds with the landscape she surveys. Her face is partially obscured, adding to the mystery of her emotions.

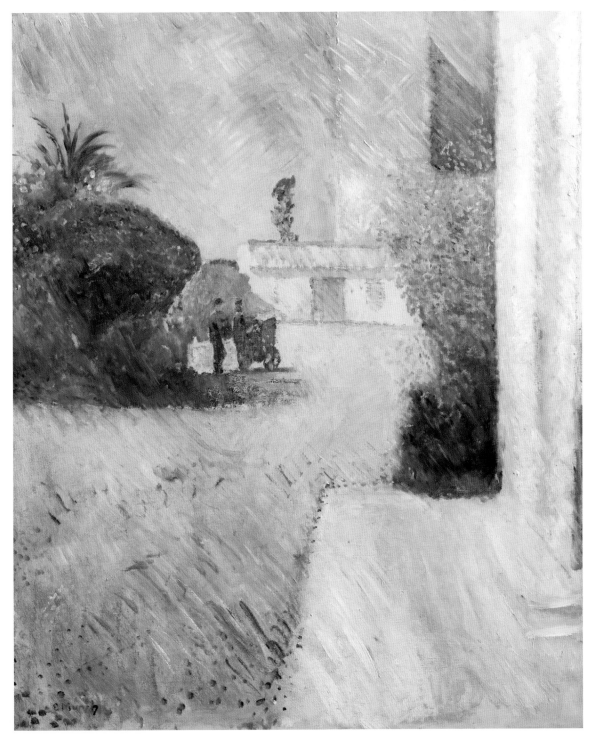

Sunshine, Nice, 1891
Oil on canvas, 65 x 54 cm (25 x 21 in)
• Private Collection

Buildings seem to shimmer, indicating the heat of the day. Placing people in the background humanizes this courtyard scene of an elegant building with tall columns. Shady bushes do not give much respite from the sun.

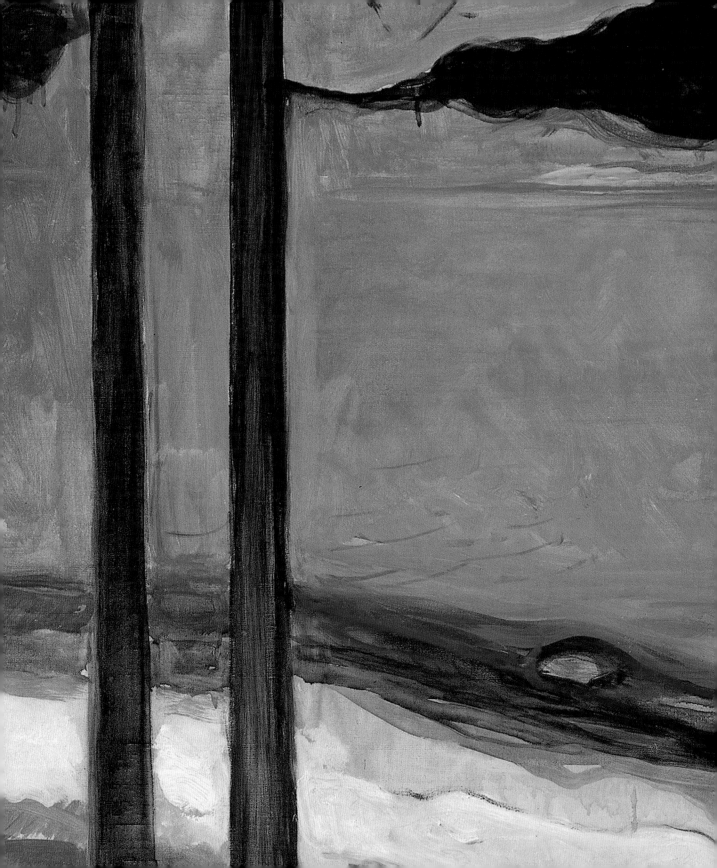

Life, Love & Death

In his 'Frieze of Life', subtitled 'A Poem about Life, Love and Death', Munch sought to explore these key themes of human existence, as seen through these artworks, featured in or heavily sympathetic to the Frieze.

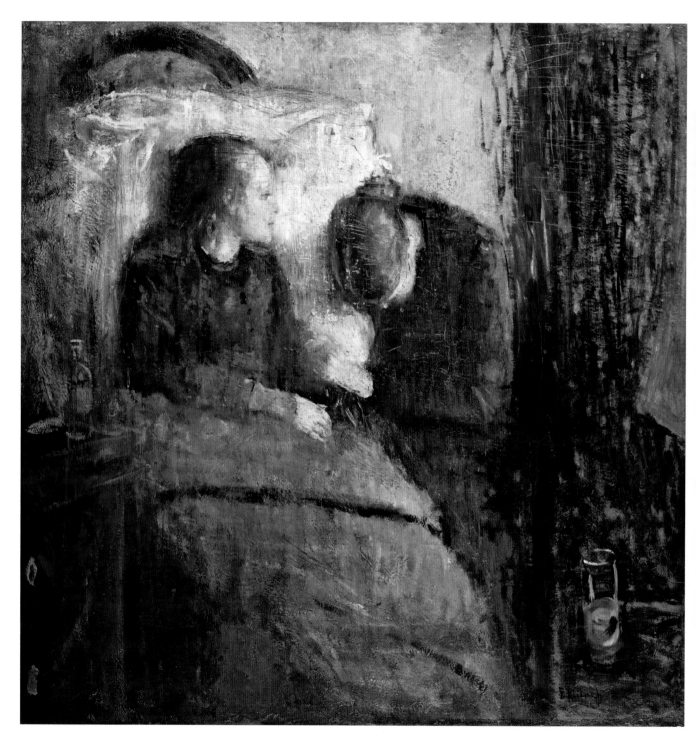

The Sick Child, 1886
Oil on canvas, 119.5 x 118.5 cm (47 x 46 in)
• Nasjonalgalleriet, Oslo

Munch called this 'a breakthrough in my art'. A woman, his aunt Karen Bjolstad, is overcome by a child's suffering. Yet the sufferer seems stoic and composed, perhaps because she does not know her grim fate. The artist did six versions of this painting of his elder sister Sophie, who died of tuberculosis at the age of 15.

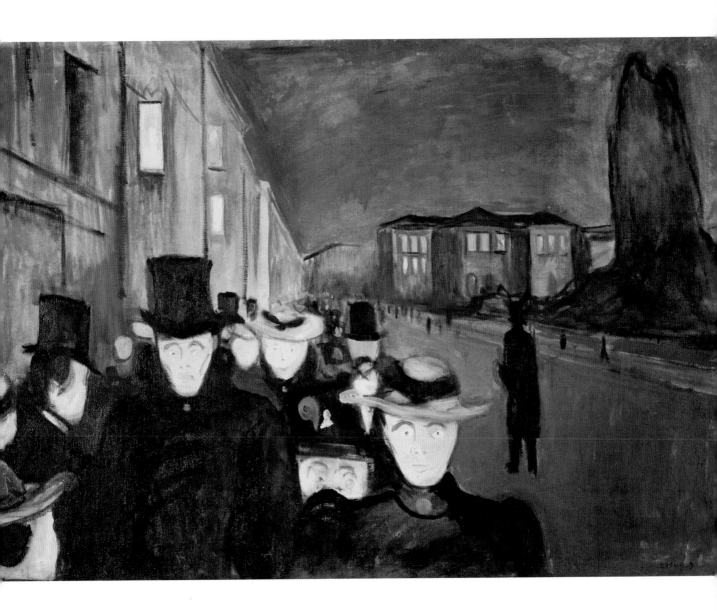

Evening on Karl Johan Street, 1892
Oil on canvas, 84.5 x 121 cm (33 x 48 in)
• Rasmus Meyers Samlinger, Bergen

People with white haunted faces, like a mass of zombies, move in one direction, while a man in a long coat walks the opposite way in Christiania, now Oslo. It is theorized that the man alone is the artist, alienated from humanity, yet longing for connection.

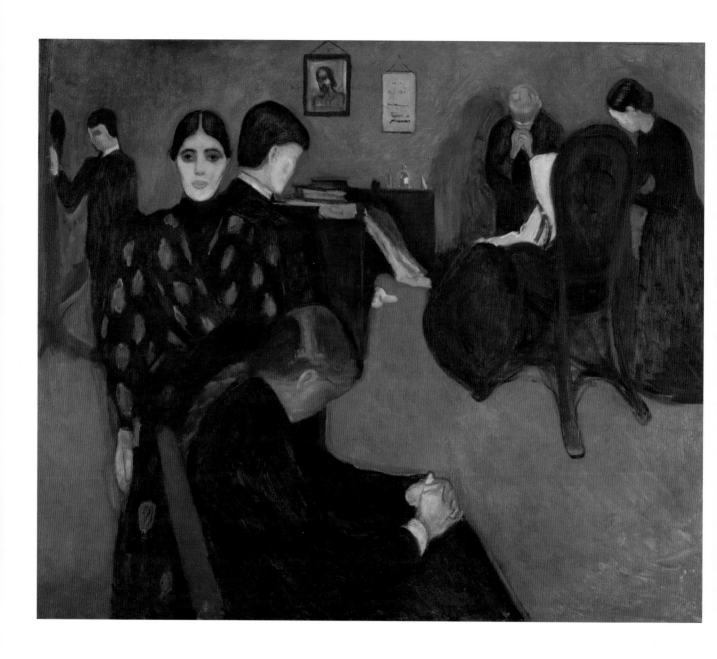

Death in the Sickroom, 1893
Oil on canvas, 134 x 160 cm (53 x 63 in)
• Munch-museet, Oslo

An autobiographical painting about the death of his beloved sister Sophie at the age of 15, sister Laura sits with head bowed, sister Inger stands behind her, along with the artist, all grieving as if alone.

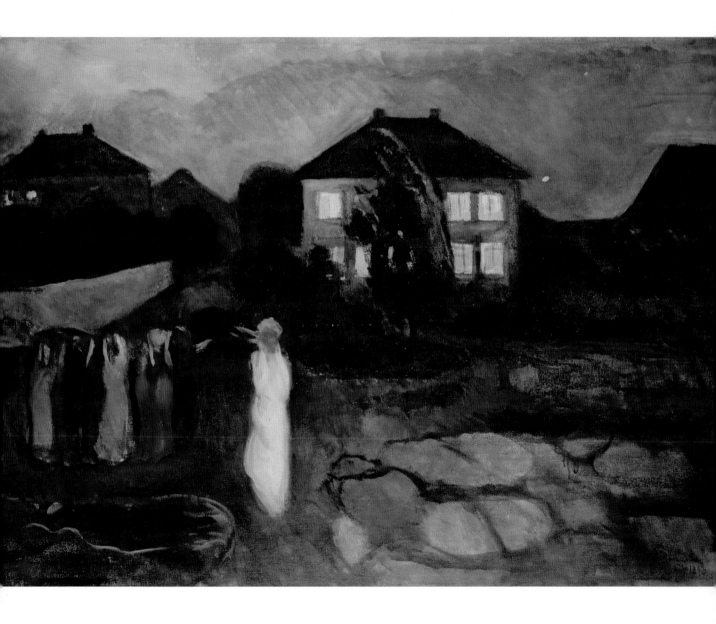

The Storm, 1893
Oil on canvas, 91.8 x 130.8 cm (36 x 51 in)
• Christian Mustad Collection, Oslo

Facing rather than fleeing this weather event, women cover their ears from the wind and rain. Safe harbour is yards away in the house with illuminated windows, but they stand transfixed.

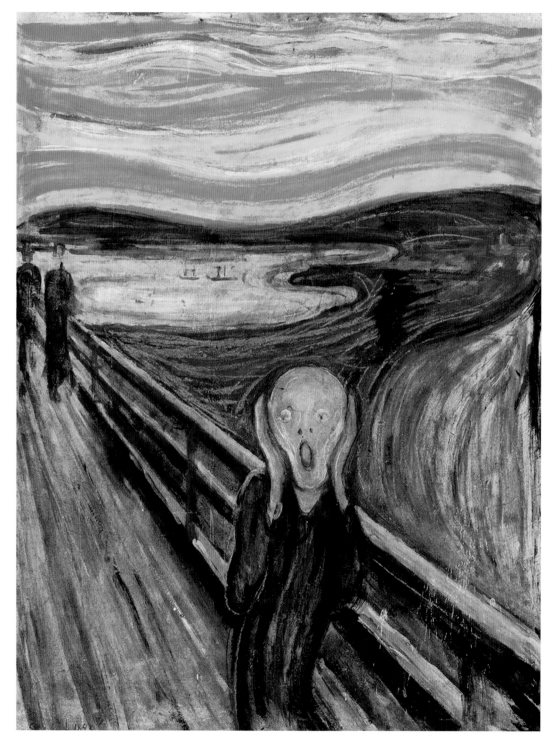

The Scream, 1893
Oil, tempera and pastel on cardboard,
91 x 73.5 cm (36 x 29 in) • Nasjonalgalleriet, Oslo

Munch's most famous painting exemplifies Norwegian Expressionism. The angst-ridden human condition has never been so superbly and unassailably conveyed by an androgynous figure emitting a cry from the heart.

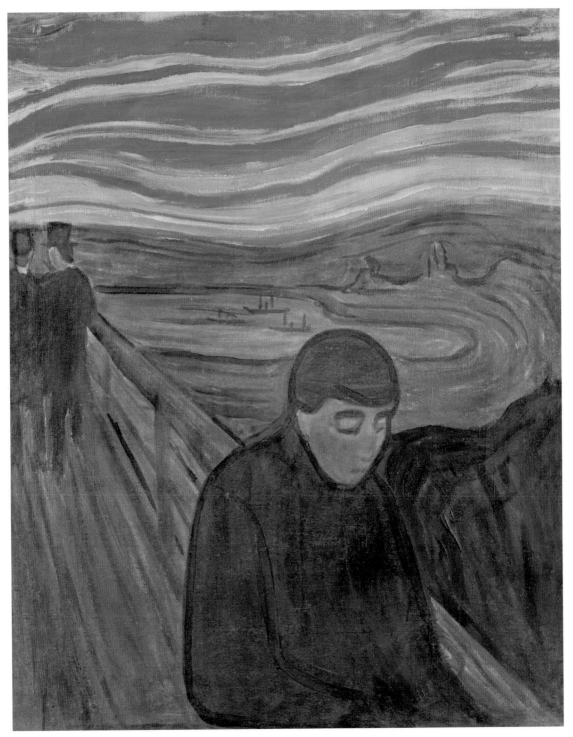

Despair, 1893
Oil on canvas, 92 x 72.5 cm (36 x 29 in)
• Munch-museet, Oslo

This self-portrait, set against the bay of Christiania, is about the artist's regretful return to Norway, feeling a failure after he had gambled away his scholarship money and had not sold enough paintings.

Woman in Three Stages (Sphinx), 1893–95
Oil on canvas, 164 x 250 cm (64 x 98 in)
• Rasmus Meyers Samlinger, Bergen

The purity and innocence of youth on the left, the full-bodied sexuality of womanhood, and the shadowy figure of the aging woman on the right represent femaleness as both desirable and mysterious to men.

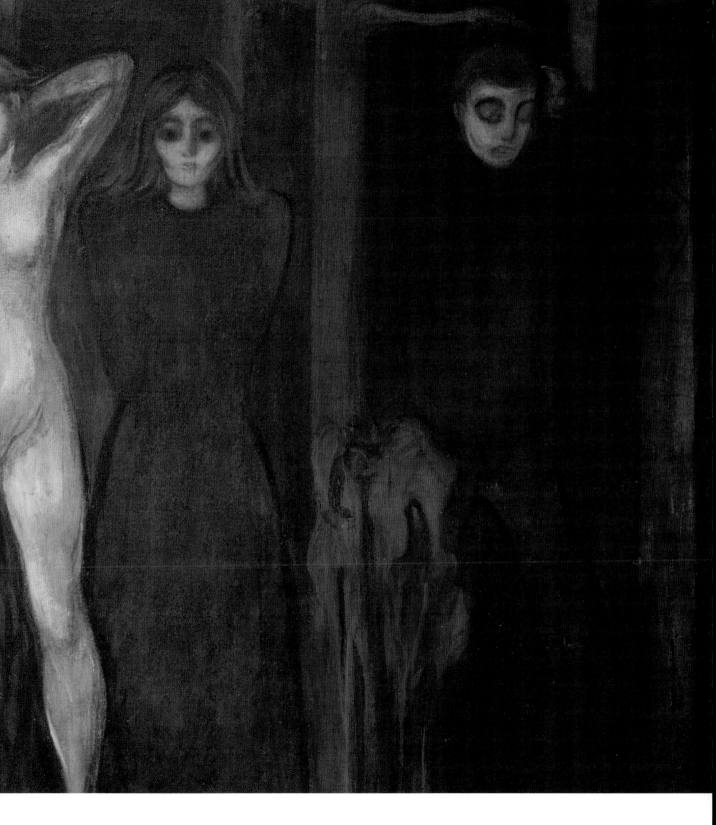

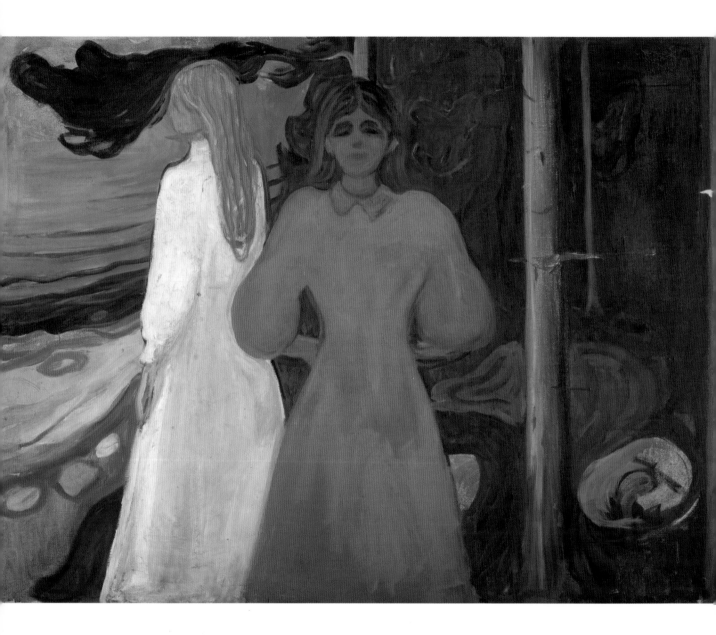

Red and White, 1894
Oil on canvas, 93 x 125 cm (37 x 49 in)
• Munch-museet, Oslo

Red and white – passion and purity – two key expressions of love embodied here by women.
The stances of a woman boldly facing the viewer with another to the left facing away is strongly
reminiscent of *Woman in Three Stages (Sphinx)*, 1893–95 (*see* page 54).

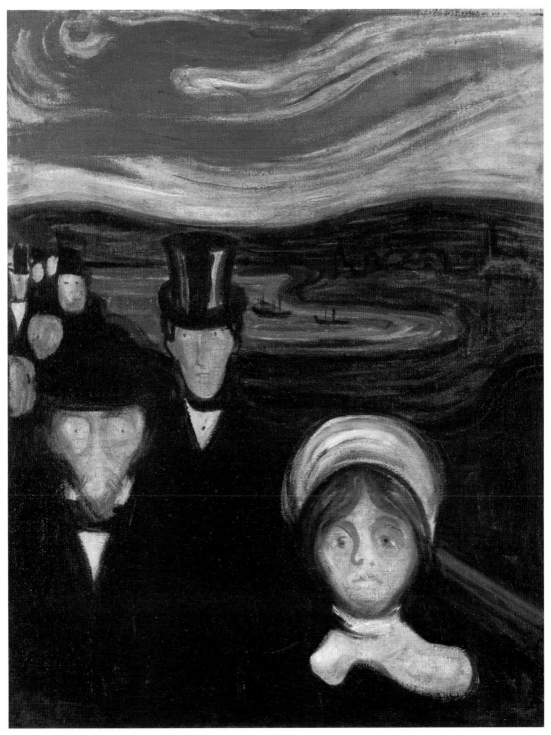

Anxiety, 1894
Oil on canvas, 94 x 73 cm (37 x 29 in)
• Munch-museet, Oslo

A woman holds her throat as if choking, though the people behind her are unaware.
Or is she troubling herself with the existential questions of life?

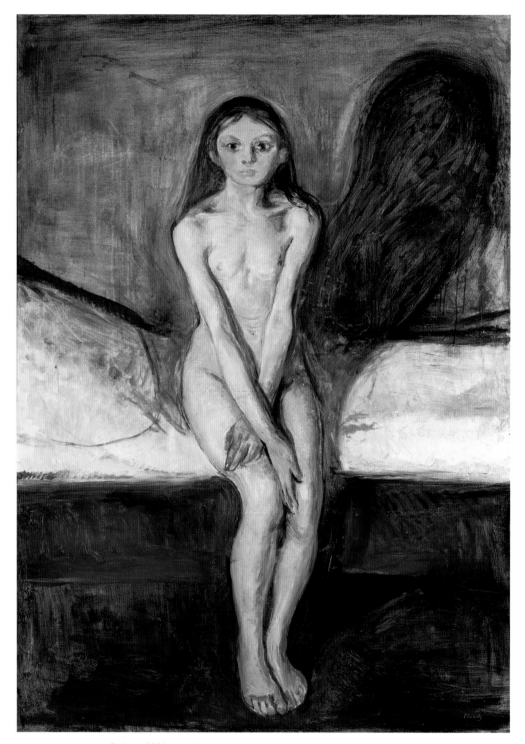

Puberty, 1894
Oil on canvas, 151.5 x 110 cm (60 x 43 in)
• Nasjonalgalleriet, Oslo

With her hands awkwardly crossed, this modest young woman is guarded and wary, fearful of what may come next. Her shadow spirit hovers behind her, perhaps a looming fear of the unknown or the liberation of her sexual awakening.

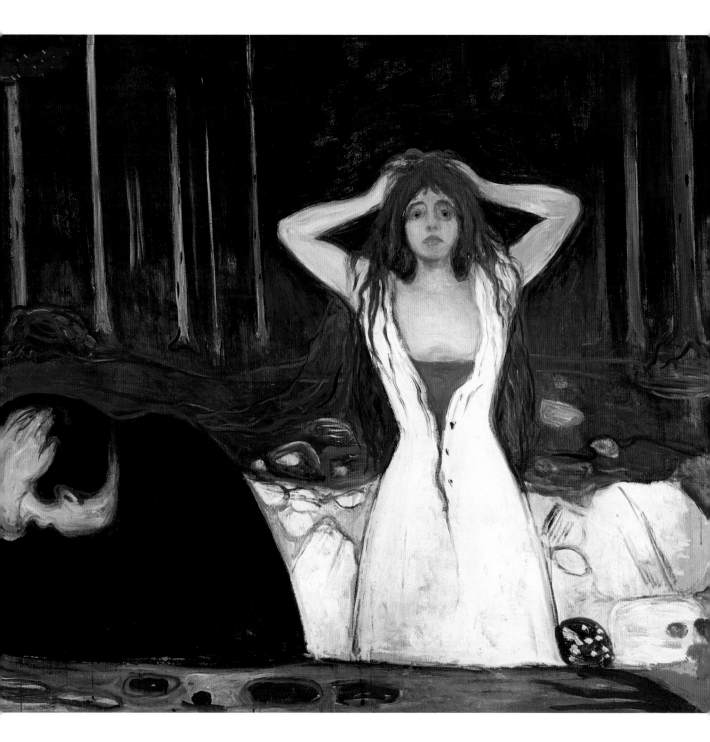

Ashes, 1894
Oil on canvas, 120.5 x 141 cm (47 x 56 in)
• Nasjonalgalleriet, Oslo

From a bed on the forest's edge, love has been consummated by a man who appears despondent and a woman ready to get dressed. Ashes could be referring to the result of lovemaking, when passionate energy leaves nothing in its path.

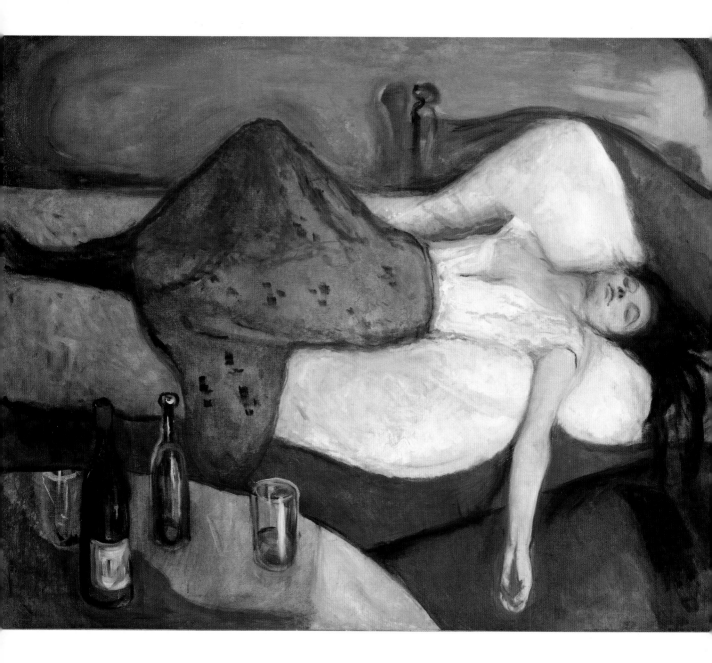

The Day After, 1894–95
Oil on canvas, 115 x 152 cm (45 x 60 in)
• Nasjonalgalleriet, Oslo

Shown to a shocked public in 1909 at the Nasjonalgalleriet in Oslo, this masterpiece trumpets
the hedonistic pleasures of the flesh, heightened by alcoholic libations.

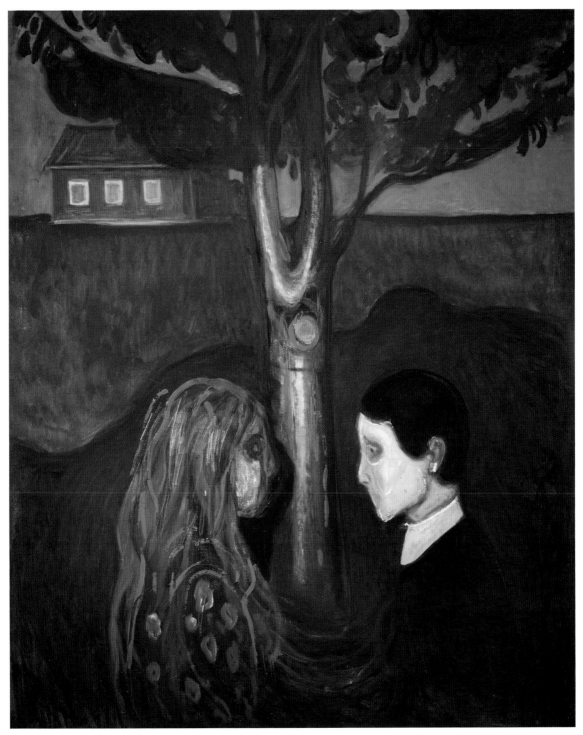

Eye in Eye, 1894
Oil on canvas, 136 x 110 cm (53 x 43 in)
• Munch-museet, Oslo

A ghostly-looking man regards a mortal woman. Perhaps she is summoning the spirit of a lost loved one. The tree that divides them acts as a plane of separation in reality or psychologically.

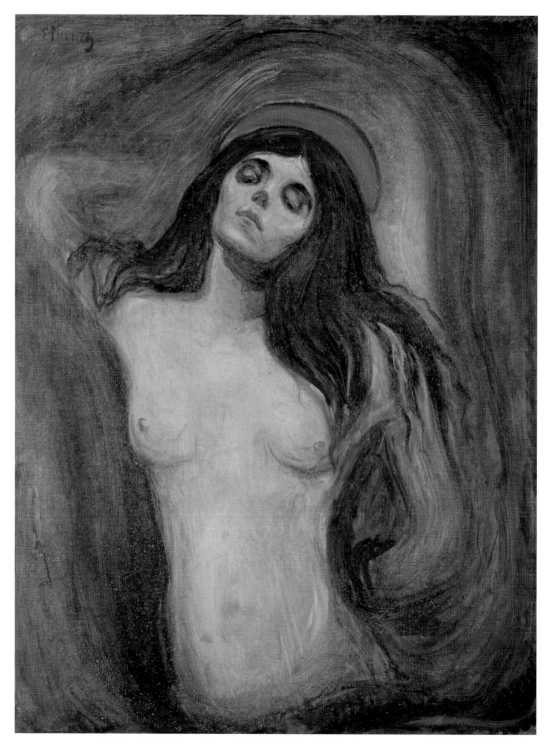

Madonna, 1894–95
Oil on canvas, 90 x 68 cm (35 x 27 in)
• Munch-museet, Oslo

Also called *The Loving Woman*, this nude woman appears in a torrid swirl of red and brown colours. Munch wrote of this image: 'Your face is full of the beauty and pain of the world because ... Death and Life are joining hands.'

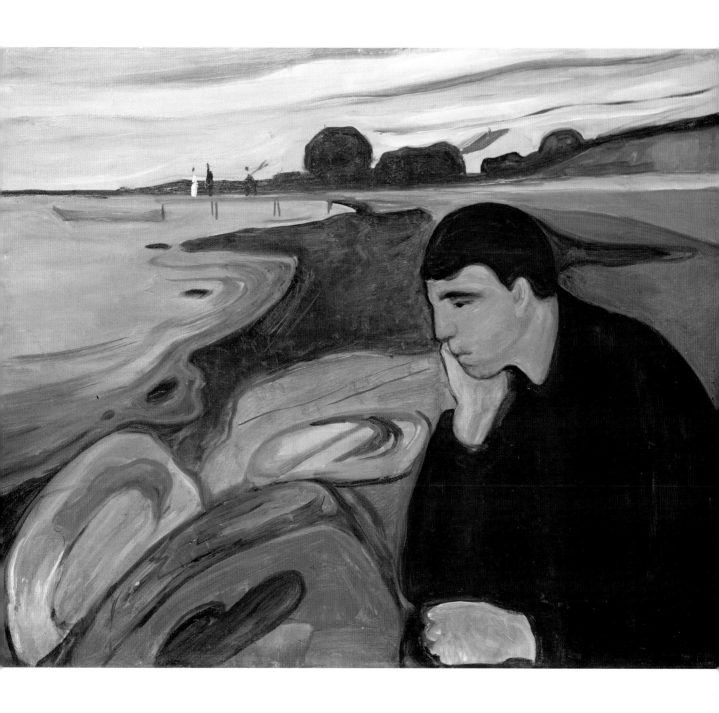

Melancholy, 1894–95
Oil on canvas, 81 x 100.5 cm (31 x 40 in)
• Bergen Art Museum, Bergen

The dejection of the man as night approaches is almost palpable. He is thought to be modelled on Munch's friend Jappe Nilssen. Free love was a tenet of Munch's intellectual circle, sometimes leading to attractions that created conflict.

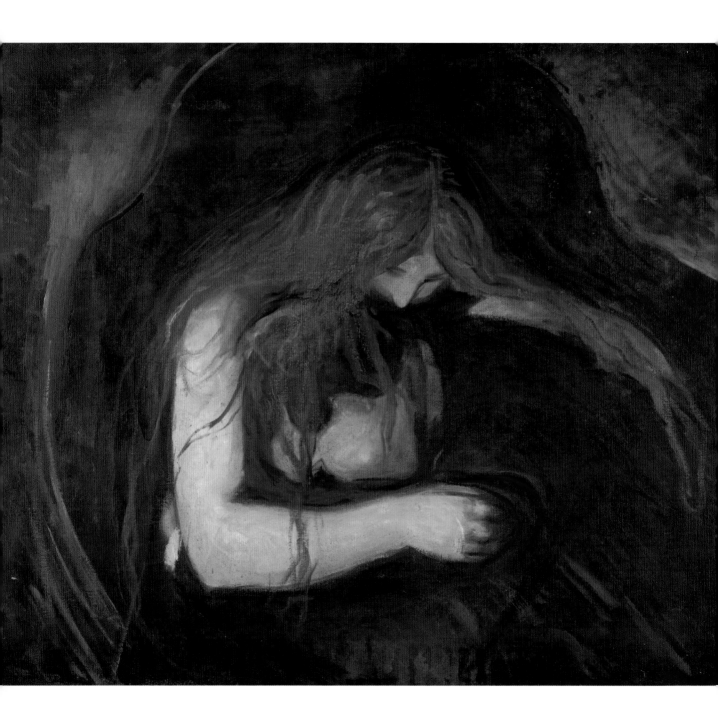

Vampire, 1895
Oil on canvas, 91 x 109 cm (36 x 43 in)
• Munch-museet, Oslo

Originally titled *Love and Pain*, this painting has been called one of the most sensual images in European art. The woman's embrace is predatory and inescapable, perhaps a reference to the clinging prostitutes Munch frequented.

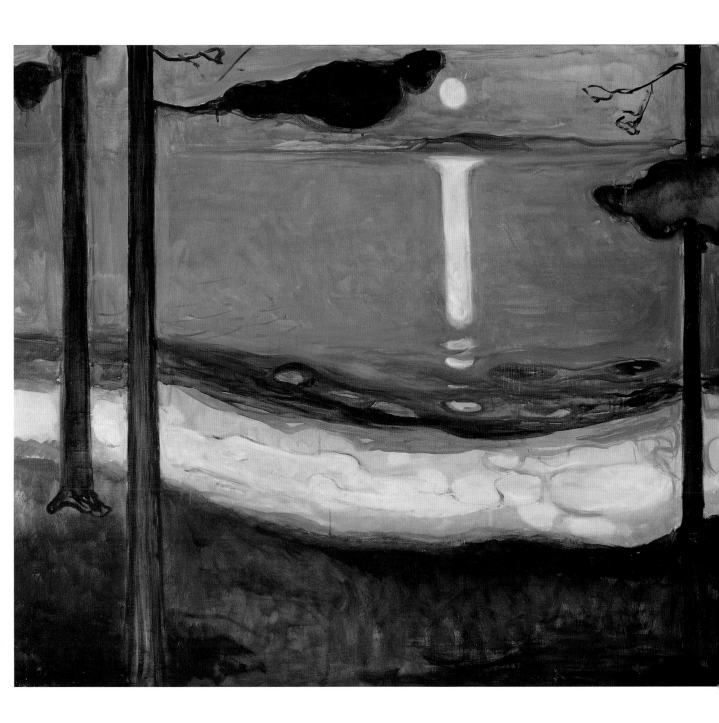

Moonlight, 1895
Oil on canvas, 93 x 110 cm (37 x 43 in)
• Nasjonalgalleriet, Oslo

It is often perceived that the moon, symbolizing the female egg, and its phallic shadow on the lake turn this landscape into a sexually symbolic painting. The reflection would not exist without the moon, a commentary on the interdependence of the genders, an issue which troubled Munch.

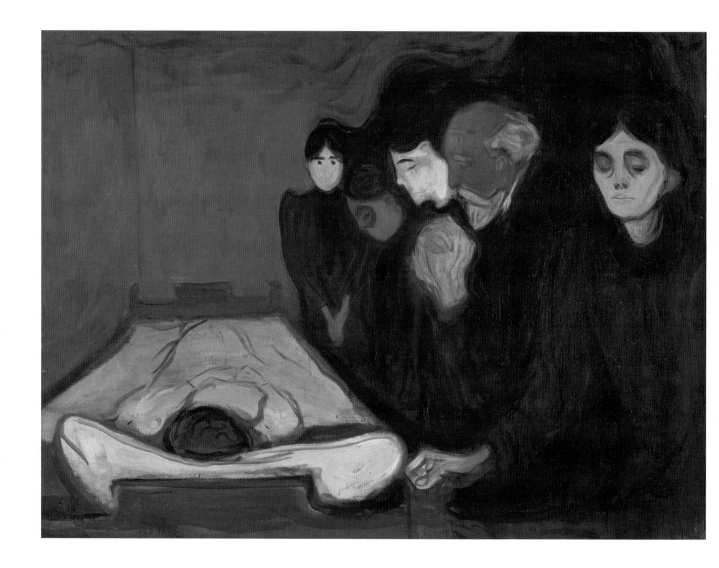

The Death Bed, 1895
Oil on canvas, 90 x 120.5 cm (35 x 47 in)
• Rasmus Meyers Samlinger, Bergen

In a cheerless red room, mourners stand near the deceased and seem almost as wooden.
Each one experiences grief alone; there is no comfort between them.

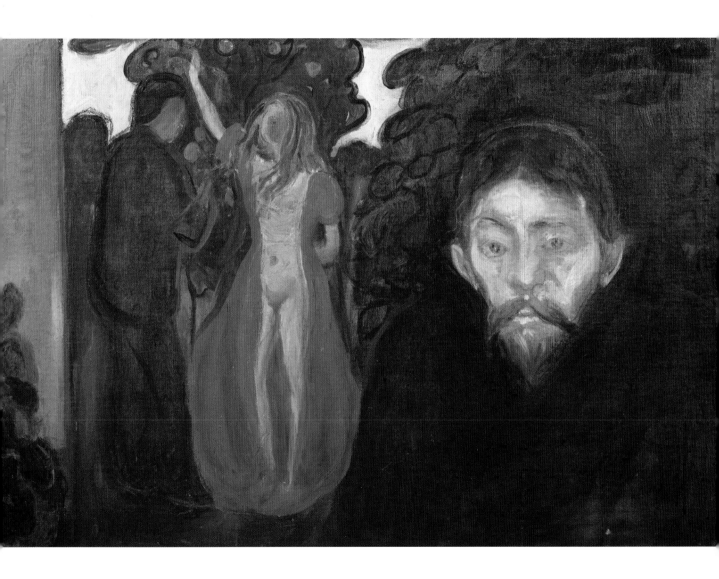

Jealousy, 1895
Oil on canvas, 67 x 100.5 cm (26 x 40 in)
• Rasmus Meyers Samlinger, Bergen

The nude woman is a temptress like Eve in the Garden of Eden. The bearded man is Munch's Polish poet friend, Stanislaw Przybyszewski, with whose wife Munch had a relationship. Note the short, nervous brushstrokes, indicative of anxiety.

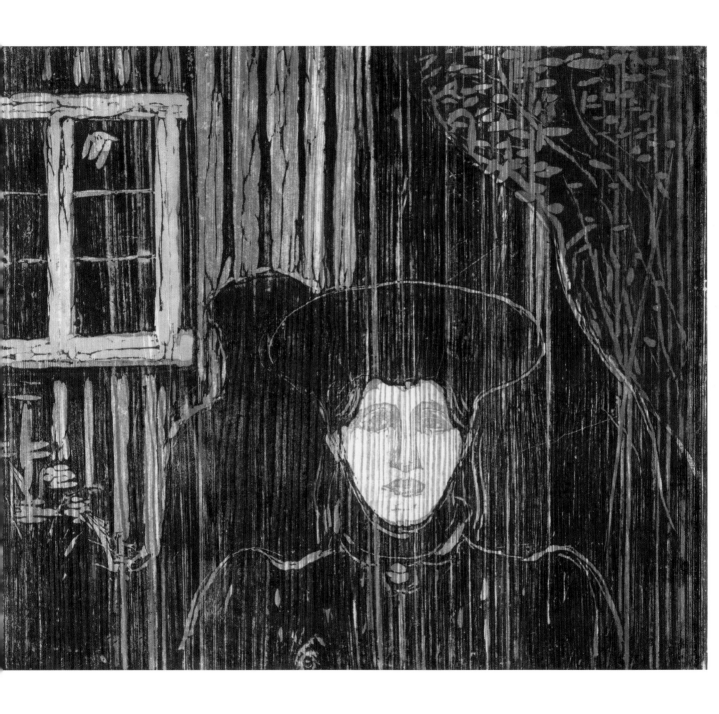

Moonlight, 1895
Woodcut, 40.5 x 46.8 cm (16 x 18 in)
• Private Collection

In this woodcut the female's pale face shining like the moon and the male shadow cast by it are intertwined, but it is the man who cannot exist without the woman.

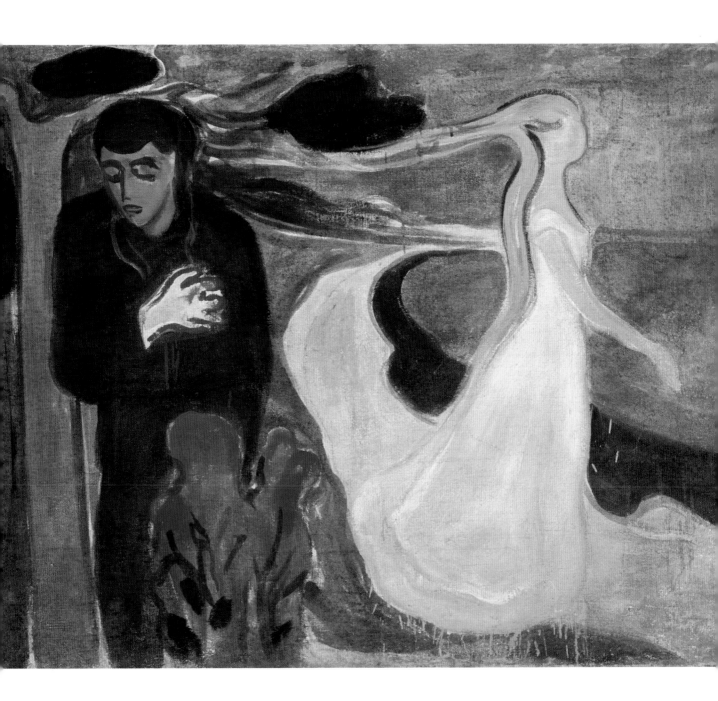

Separation, 1896
Oil on canvas, 96.5 x 127 cm (18 x 50 in)
• Munch-museet, Oslo

Holding his bleeding heart, a fresh romantic wound, a man is pained as a blonde woman walks away defiantly from him, as if she were the cause of their parting. The still sea mirrors her indifference.

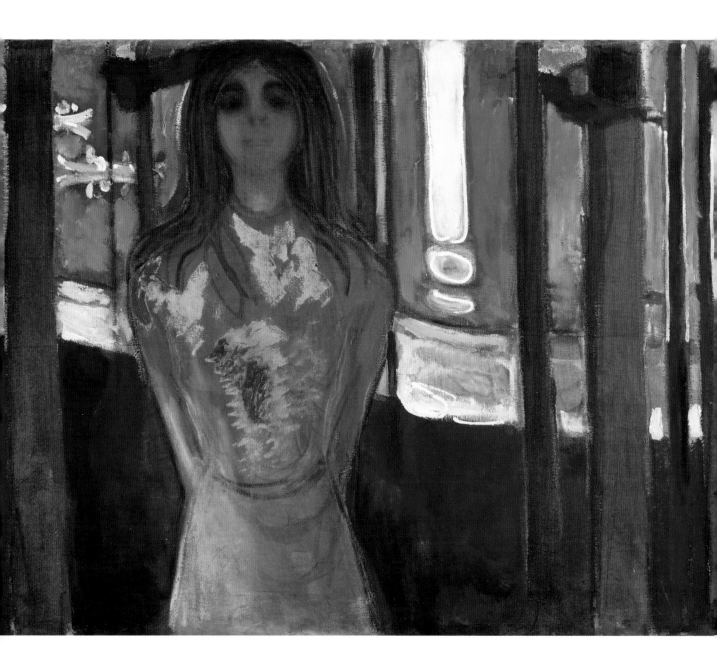

The Voice, 1896
Oil on canvas, 90 x 118.5 cm (35 x 46 in)
• Munch-museet, Oslo

Munch's cousin, Millie Thaulow, may have had a speaking voice he found compelling. Set on the shore of Åsgardstrand, this painting is his memory of the night he began a sexual affair with her.

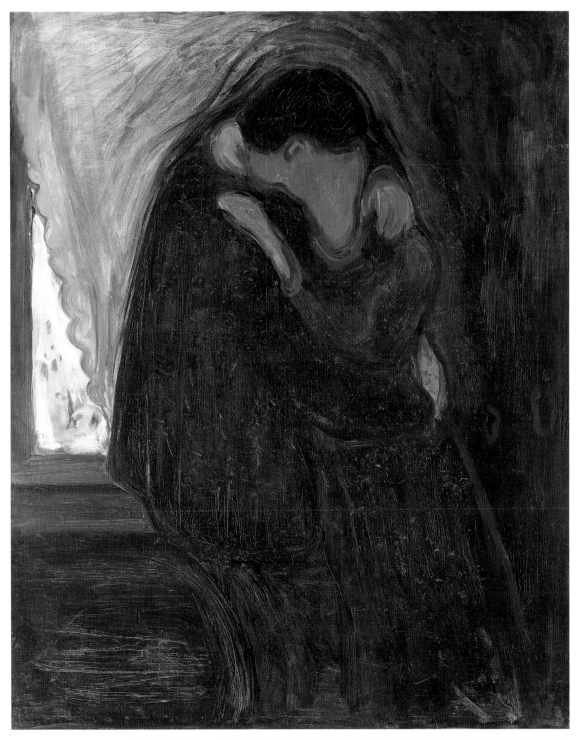

The Kiss, 1897
Oil on canvas, 99 x 80.5 cm (39 x 32 in)
• Munch-museet, Oslo

One can nearly feel the forcefulness of the man's arms at the woman's back and waist, and the passion of his lips on hers. They seem to merge into one body, as at the height of passion. It inspired the same-titled, very different painting by Gustav Klimt.

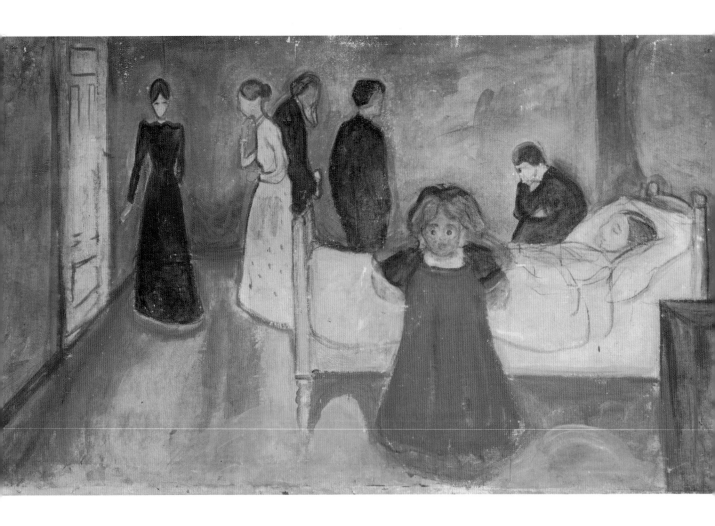

The Dead Mother and the Child, 1897–99
Oil on canvas, 104.5 x 179.5 cm (41 x 71 in)
• Munch-museet, Oslo

Again, Munch depicts the experience of grief as lonely and singular, rather than shared.
The adults in the room are oblivious to the suffering of the stunned girl. Munch's own
mother died when he was five.

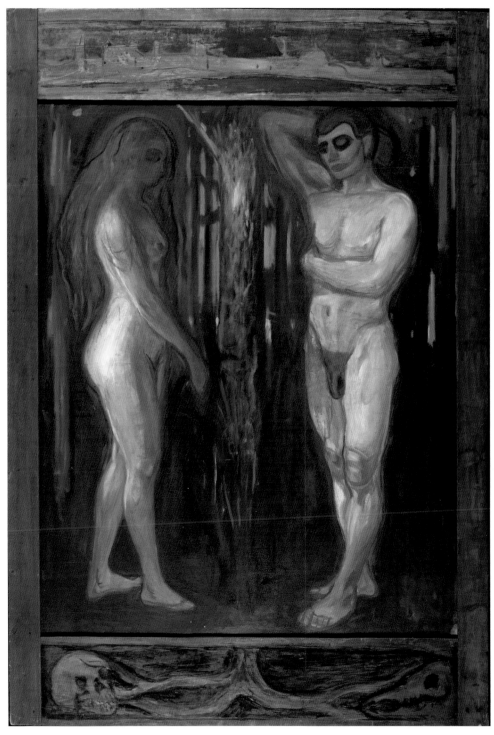

Metabolism, 1898–99
Oil on canvas, 172 x 142 cm (67 x 56 in)
• Munch-museet, Oslo

Initially called *Adam and Eve*, this painting anticipates copulation. It shows Munch's interest in the fall of man and his own pessimism about sex and love.

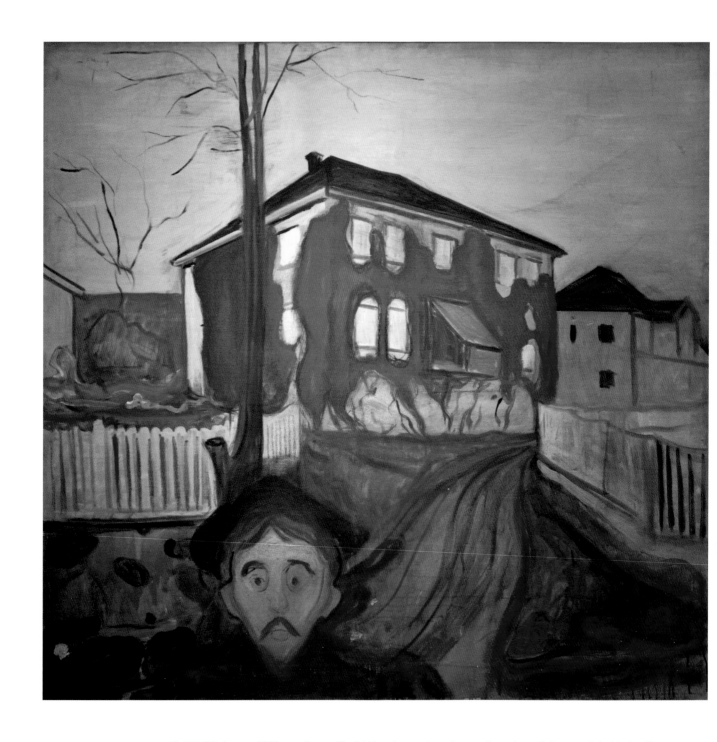

Red Virginia Creeper, 1898
Oil on canvas, 119.5 x 121 cm (47 x 48 in)
• Private Collection

A man with a frightened expression walks away from a house that appears to be blood-red in colour. What horrific scene did he initiate or witness in the house encircled by a plant, symbolic of his affair with Tulla Larsen, whose father was a wealthy wine merchant?

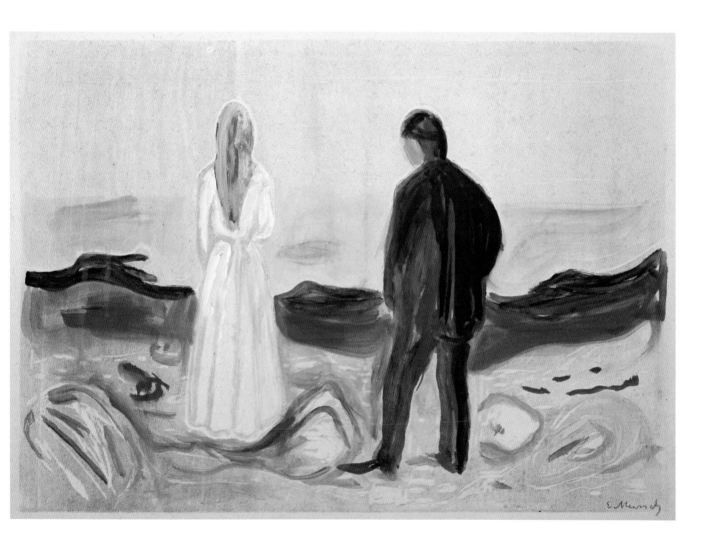

The Lonely Ones, 1899
Oil on woodcut, 39.4 x 54.6 cm (15 x 21 in)
• Private Collection

Physically separate, perhaps after an argument, this woman and man express the conflicts
Munch had about being coupled and escaping loneliness. He did several versions of this theme.

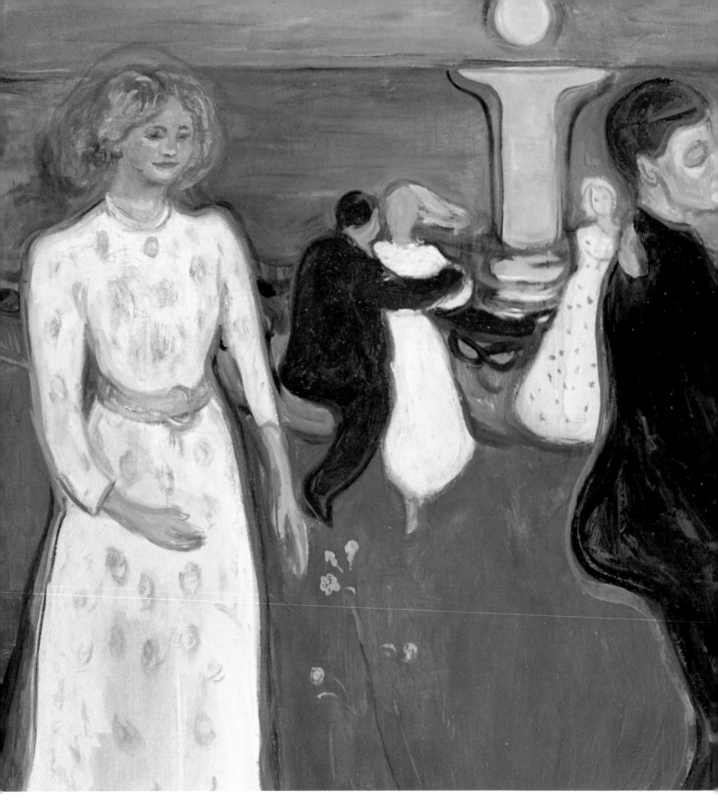

The Dance of Life, 1899–1900
Oil on canvas, 125.5 x 190.5 cm (49 x 75 in)
• Nasjonalgalleriet, Oslo

The compelling figures of two women without partners creates tension and excitement
in this leisurely narrative. All the women are though to resemble Munch's love,
Tulla Larsen.

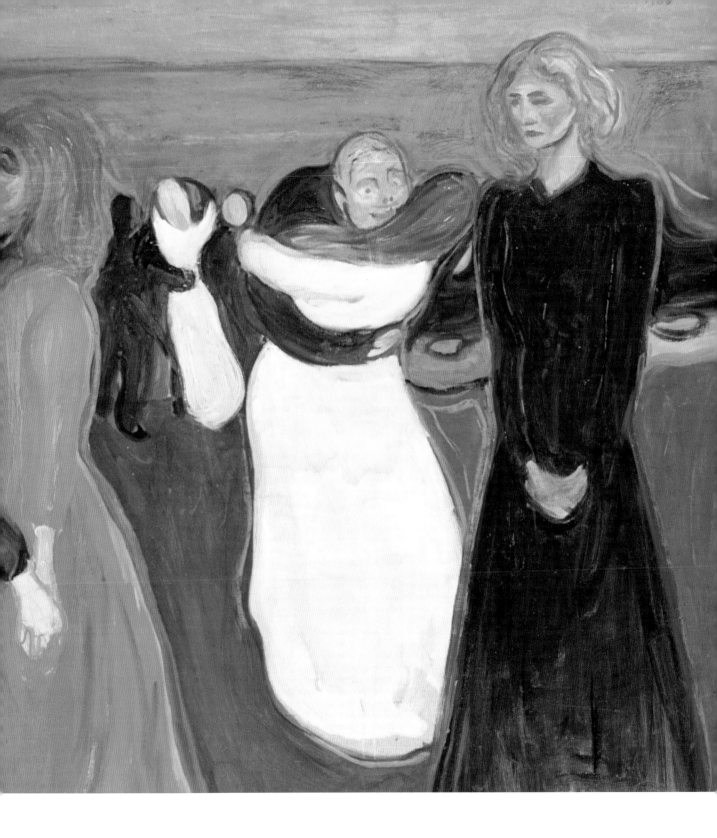

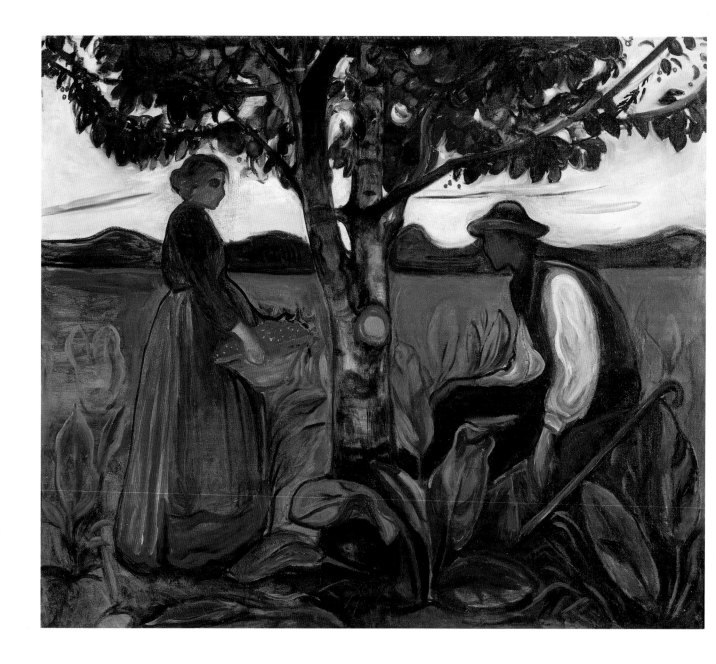

Fertility, 1899–1900
Oil on canvas, 120 x 140 cm (47 x 55 in)
• Private Collection

The title could refer to the land or the couple working on it. The woman holds a basket, a gesture of openness and reception, symbolic of her attraction to the man.

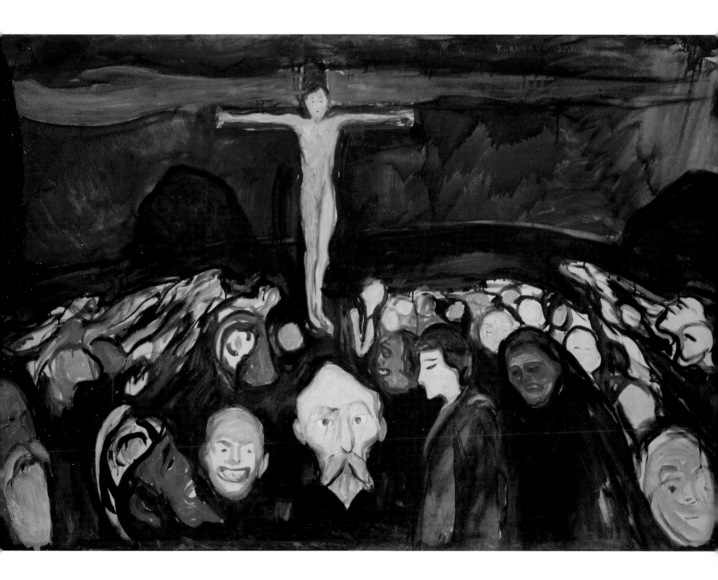

Golgotha, 1900
Oil on canvas, 80 x 120 cm (31 x 47 in)
• Munch-museet, Oslo

To equate his suffering with the crucified son of God is an act of hubris, but Munch was considerably pained by being pilloried in the press, misunderstood by the public and sometimes shunned by colleagues.

Turn of
the Century

Though he was struggling
with various crises and
emotional issues in his
personal life, Munch's art
was still prospering in the
early 1900s.

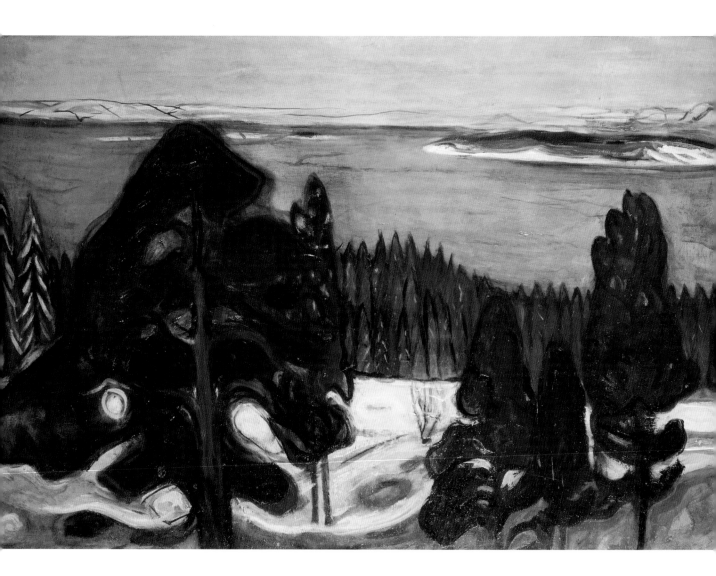

Winter Night, 1900
Oil on canvas, 80 x 120 cm (31 x 47 in)
• Kunsthaus, Zurich

Employing an often-used technique of vertical and horizontal elements, Munch portrays the impenetrability of the distant forest in the grip of the coldest and seemingly longest season.

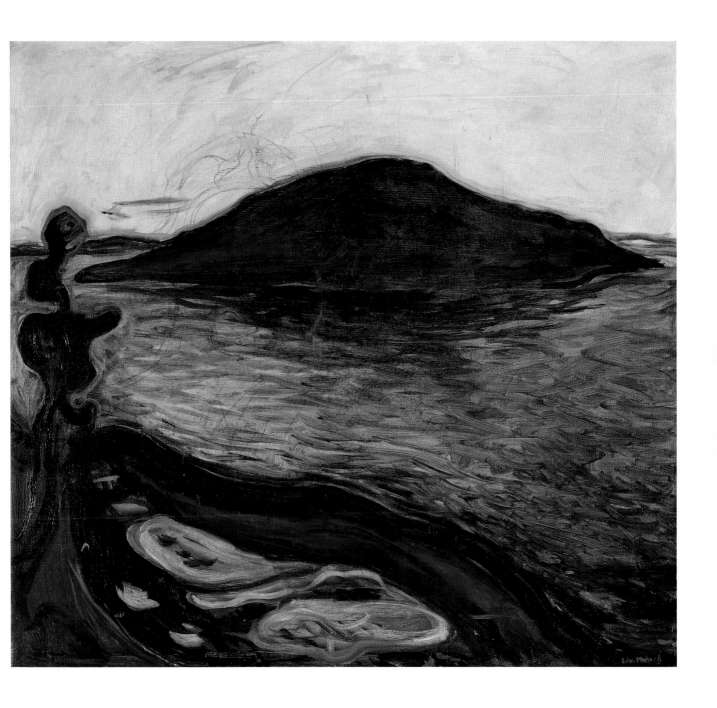

The Island, 1900–01
Oil on canvas, 99 x 108 cm (39 x 43 in)
• Private Collection

Rising ominously from the sea like a leviathan, its topography blurred by darkness, the island is the geographical correlative of Munch, who prized and probably also cursed his years of solitude and separateness from others.

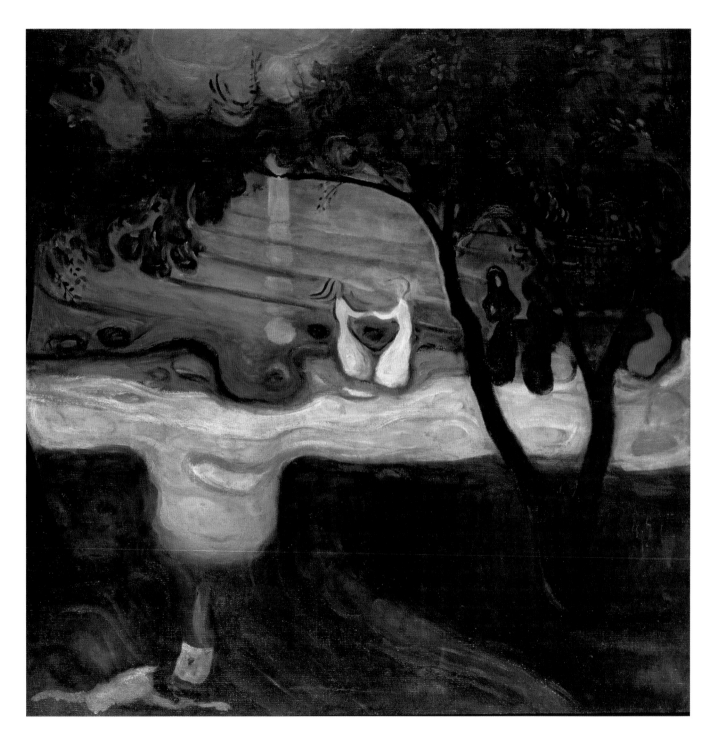

Dance on Shore, 1900–02
Oil on canvas, 95.5 x 98.5 cm (38 x 39 in)
• Narodni Galerie, Prague

This courtship dance is of girls playing while watched by women in black, like mourners or widows. The water's pink shadow is thought to symbolize the male member, the long beam of moonlight being a recurring symbol in Munch's art.

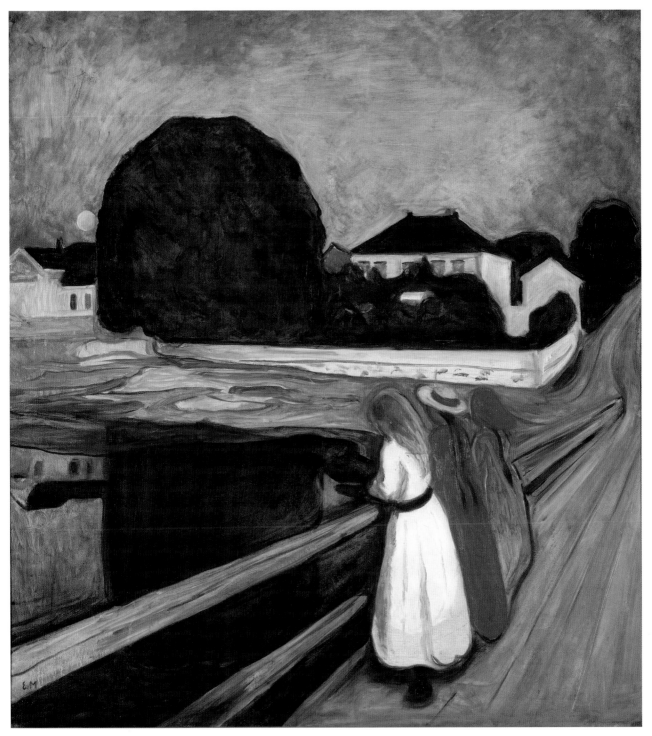

Girls on the Pier, c. 1901
Oil on canvas, 136 x 125 cm (54 x 49 in)
• Nasjonalgalleriet, Oslo

Three females stare at the water with faces unseen. The water with its dark mysteries represents the unknown, the future, while the white houses symbolize domesticity and family. Several versions, including woodcuts and lithographs, were created of this theme about the weight of anticipation.

Young Girl in a Red Hat, 1900
Oil on wood, 58 x 46.4 cm (23 x 18 in)
• Van der Heydt Museum, Wuppertal

With her matching red dress, the girl is a little doll, the picture of pre-pubescent cuteness. The sexually charged colour is a counterpoint to the child's appropriate ignorance of her eventual flowering into adolescence.

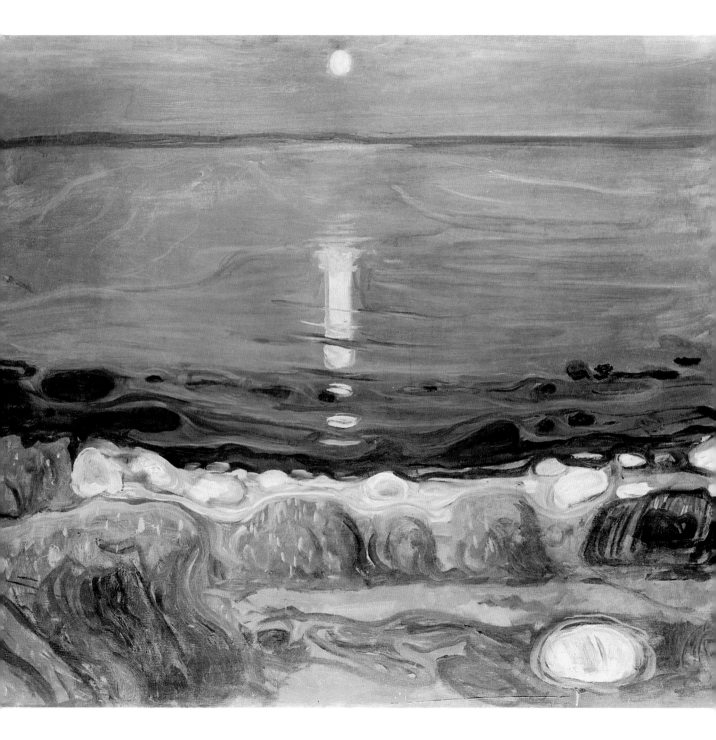

Summer Night at the Beach, 1902
Oil on canvas, 103 x 120 cm (40 x 47 in)
• Private Collection

This image affords a romantic view of the all-night sun and its penile reflection in calm waters. The long beam of moonlight is an unusual but recurring motif in Munch's works (*see* page 65).

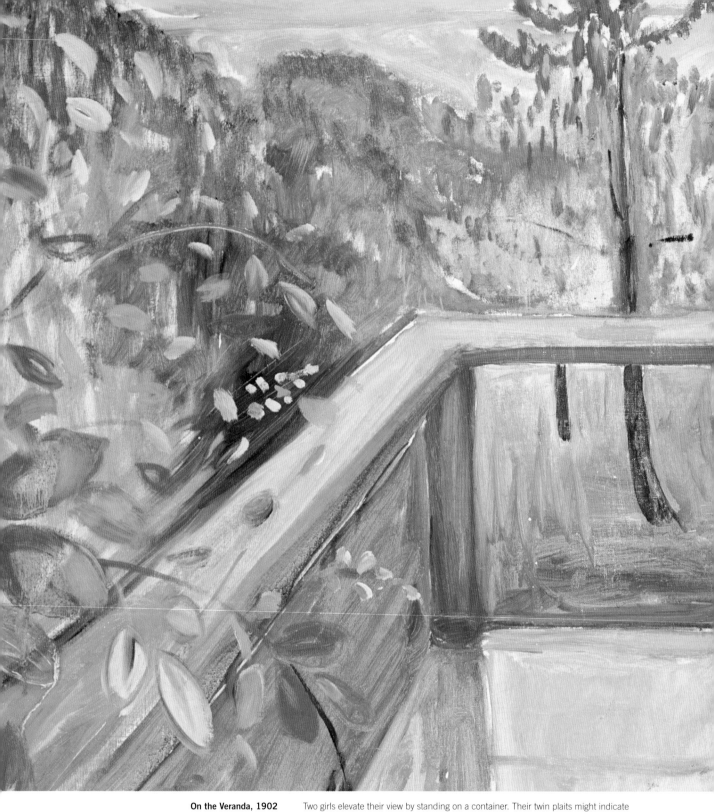

On the Veranda, 1902
Oil on canvas, 86 x 115 cm (34 x 45 in)
• Nasjonalgalleriet, Oslo

Two girls elevate their view by standing on a container. Their twin plaits might indicate closeness, perhaps sisterhood.

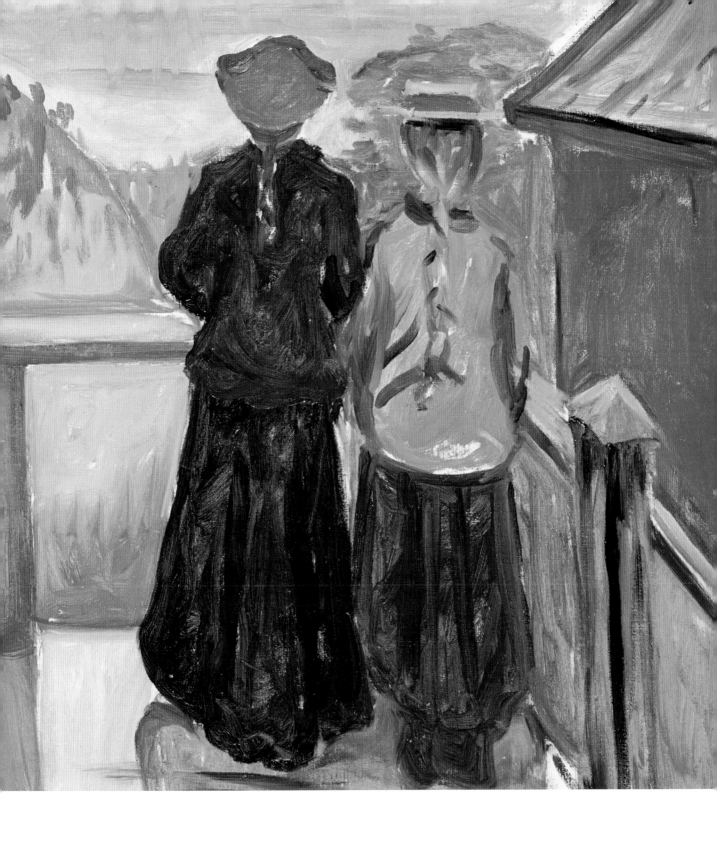

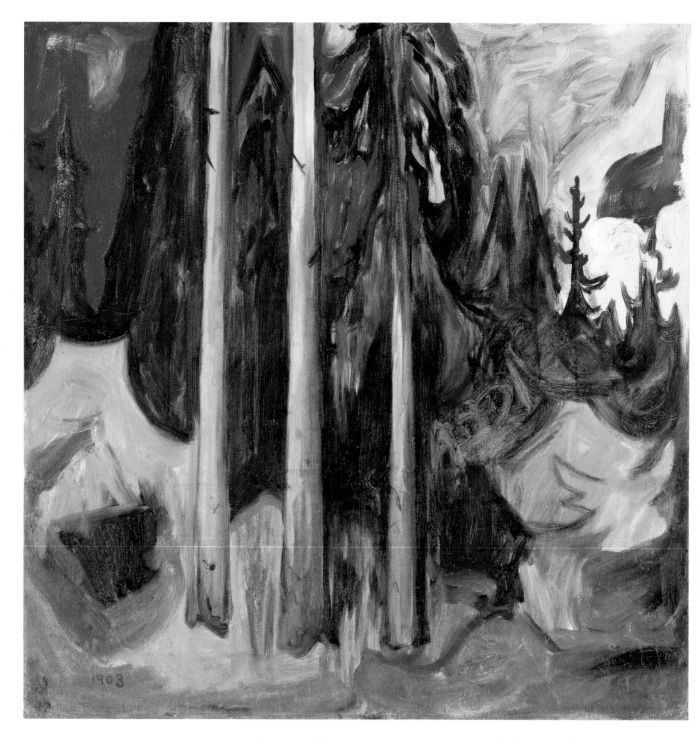

Wood, 1903
Oil on canvas, 82.5 x 81.5 cm (32 x 32 in)
• Munch-museet, Oslo

Three tall trees obscure the dark greenery beyond their trunks. They could be seen as stiffly phallic, especially as they front a dark, mysterious place, signifying the experience of sex, which is unknown with each new partner.

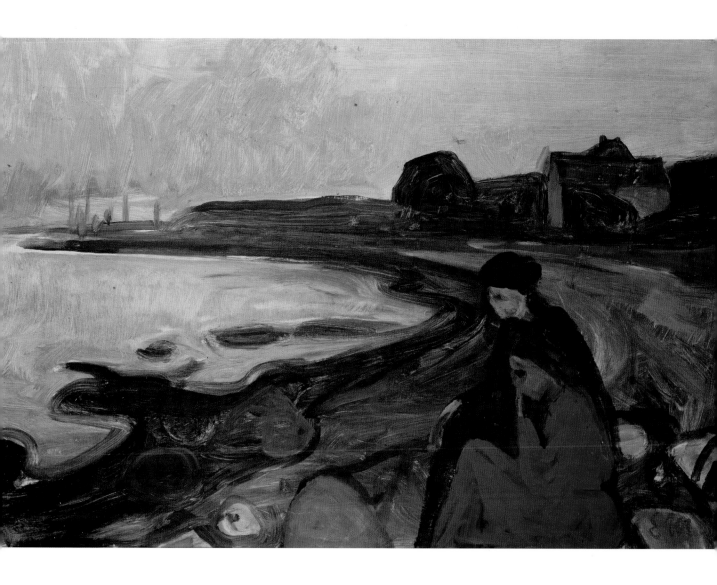

From Åsgardstrand, 1903
Oil on canvas
• Bergen Art Museum

A woman on the shore as the sky darkens is a figure of loneliness. The blue-faced woman near her is either sickly or a ghost. Her indistinct features in this cheerless setting make her a Rorschach test for the viewer.

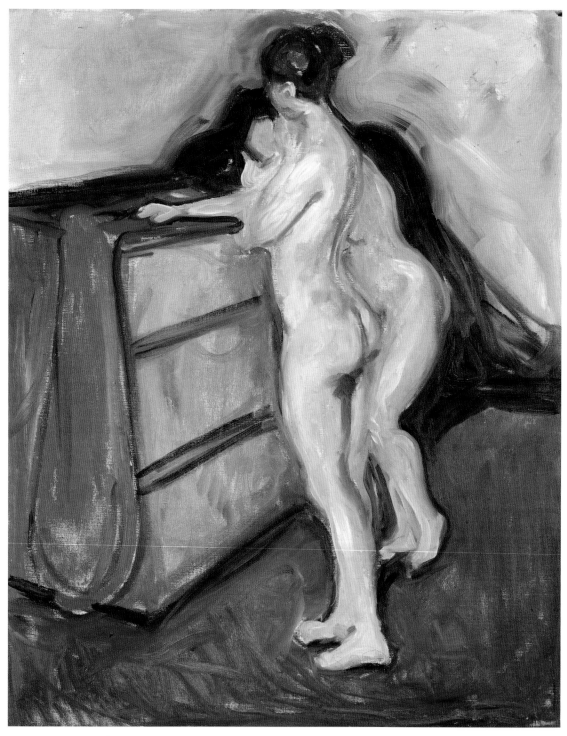

Two Female Nudes, 1903
Oil on canvas, 85.5 x 69.5 cm (34 x 27 in) • Museum fur
Kunst und Kultur, Westfalisches Landesmuseum, Munster

Munch's views on women were complicated – he felt love, understanding, repulsion and fear
for them. There is something both sexual and vulnerable about the depiction of nude females.

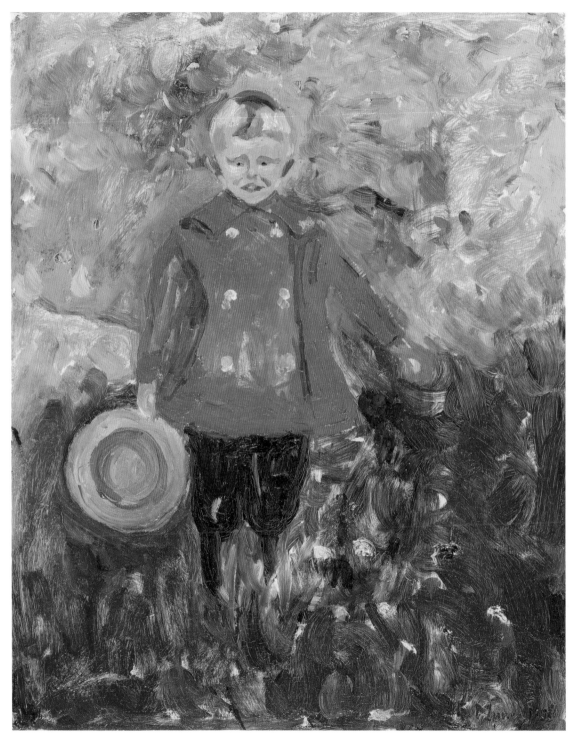

Lothar Linde with Red Jacket, 1903
Oil on wood, 50 x 40 cm (20 x 16 in)
• Museum Behnhaus Dragerhaus, Lubeck

The picture of health, radiance and charm, this is the kind of cheerful portrait that prompted female models and potential lovers to beat a path to Munch's door.

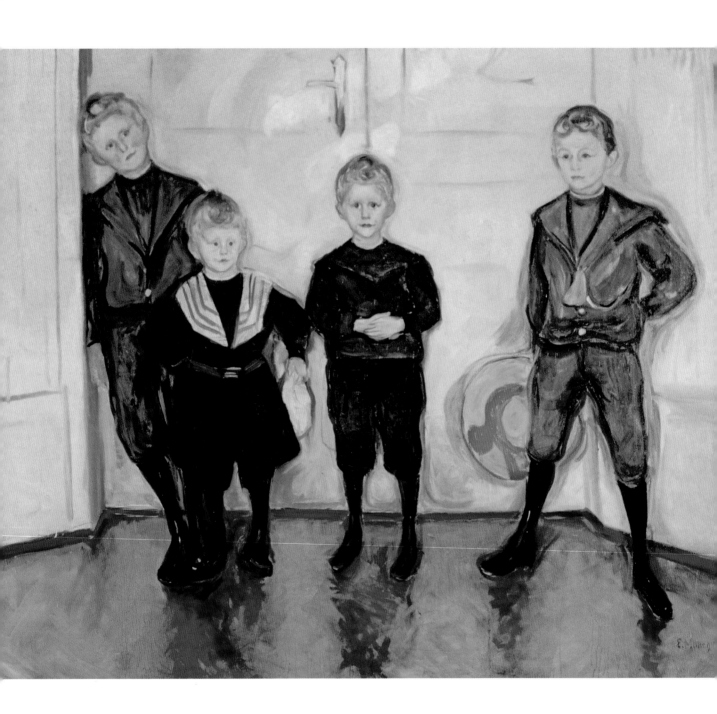

The Four Sons of Dr Linde, 1903
Oil on canvas, 144 x 195.5 cm (56 x 78 in)
• Art and Cultural History Museum, Lubeck

Well-dressed, politely behaved siblings show a facial resemblance but also an obvious
attempt to individualize themselves in their separateness and ways of holding themselves.
Dr Max Linde, the father of these boys, was an important patron of Munch's.

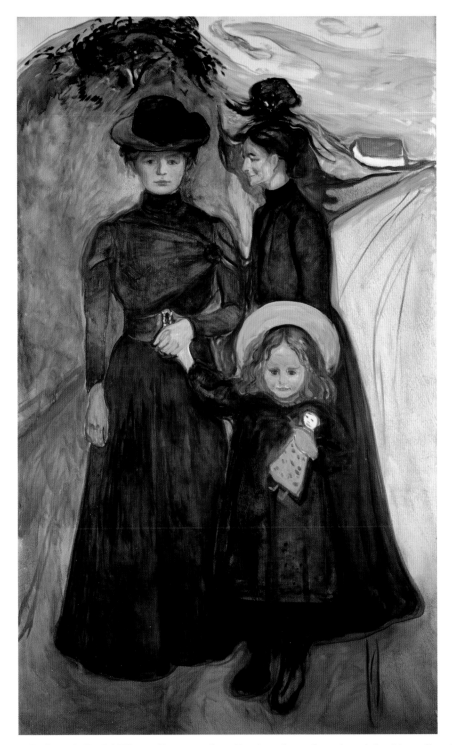

The Family on the Road, 1903
Oil on canvas
• Mielska Gallery, Stockholm

Three generations of females walk away from a house in the distance. The adult faces are placid and the child is serene. Perhaps Munch wished for himself this kind of generational continuance, though he never had children and never wed.

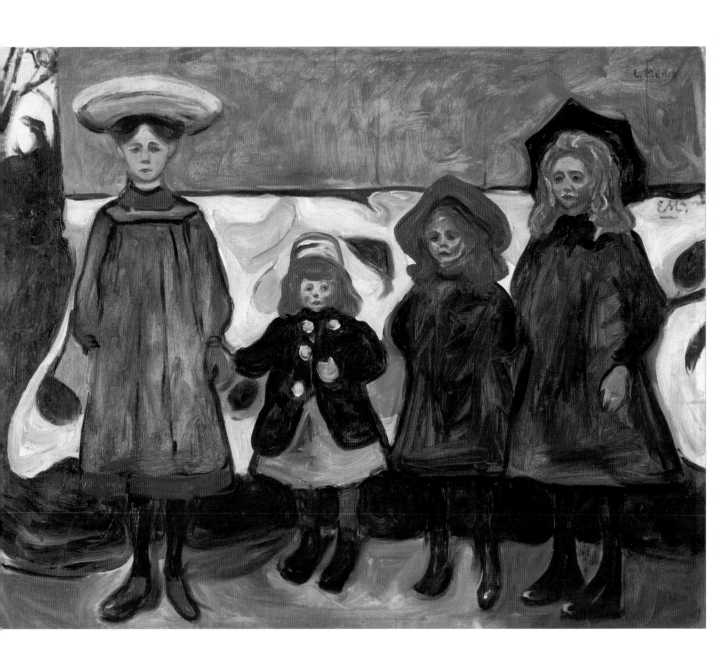

Four Girls in Åsgardstrand, 1903
Oil on canvas, 87 x 111 cm (34 x 44 in)
• Munch-museet, Oslo

Munch spotted these four girls in their Sunday best and asked their parents
if they could pose for him, accounting for their slightly stunned expressions.

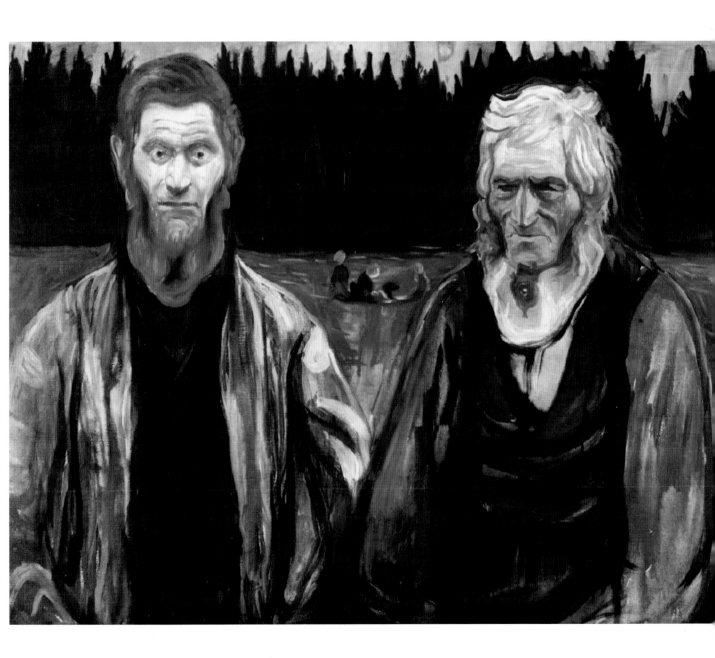

Father and Son, *c.* **1904**
Oil on canvas, 96 x 119 cm (38 x 47 in)
• Private Collection

An old man with his middle-aged son, and his daughter-in-law and grandchildren in the distance, represent the continuation of a family, something Munch studiously avoided in his life but perhaps also longed to have.

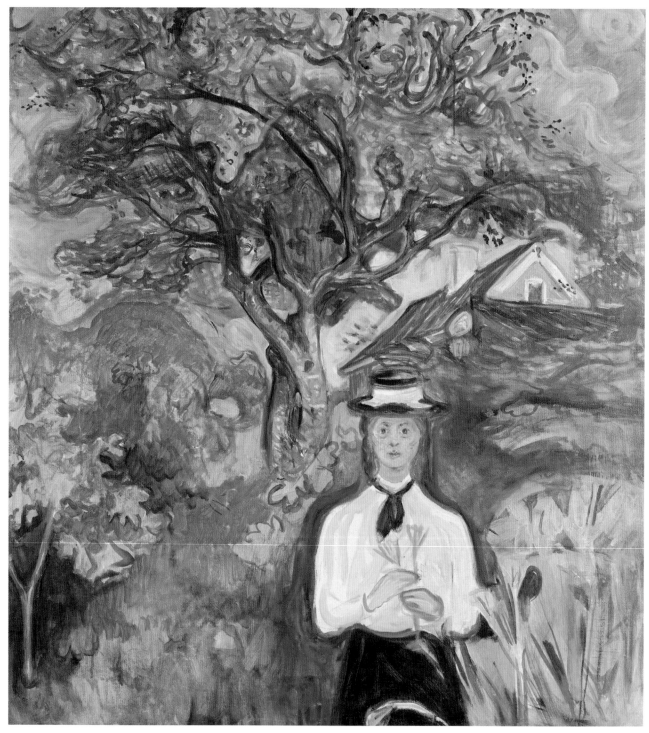

Girl under Apple Tree, 1904
Oil on canvas, 110 x 99.1 cm (43 x 39 in)
• Private Collection

This fetching young woman is an object of beauty within the lushness of nature. Standing under an apple tree as if in the Garden of Eden, she is kin to that first temptress capable, even desirous, of seduction.

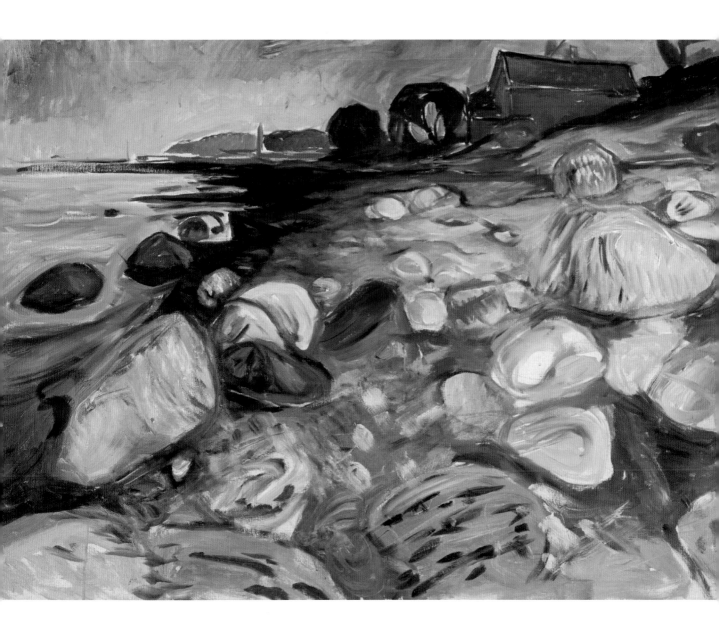

Shore with the Red House, 1904
69 x 109 cm (27 x 43 in)
• Munch-museet, Oslo

The beach, with its rocks of all different sizes and colours, symbolizes the obstacles faced in going home. Perhaps it marks a retreat for the artist from personal and professional disappointment.

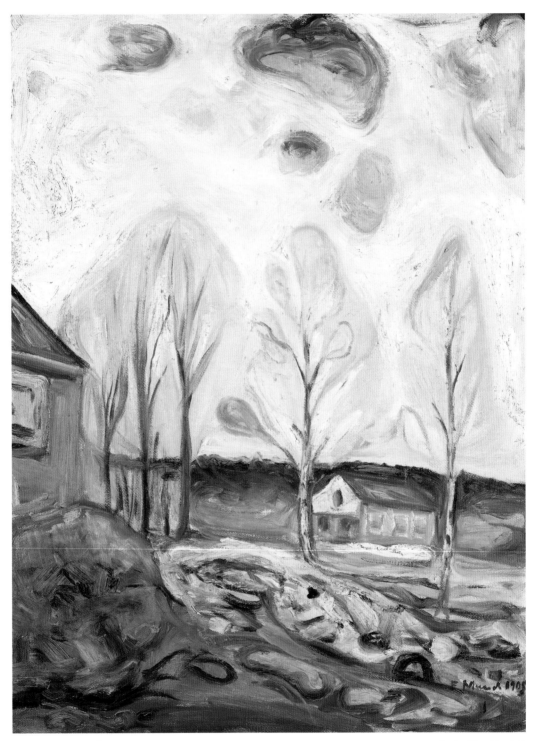

Fruhjahr Åsgardstrand, 1905
Oil on canvas, 80 x 60 cm (31 x 24 in)
• Private Collection

The house is a symbol apart from the rest of the community, reflecting Munch's relationship to the town where he spent 20 summers, having bought a house there in the late 1890s.

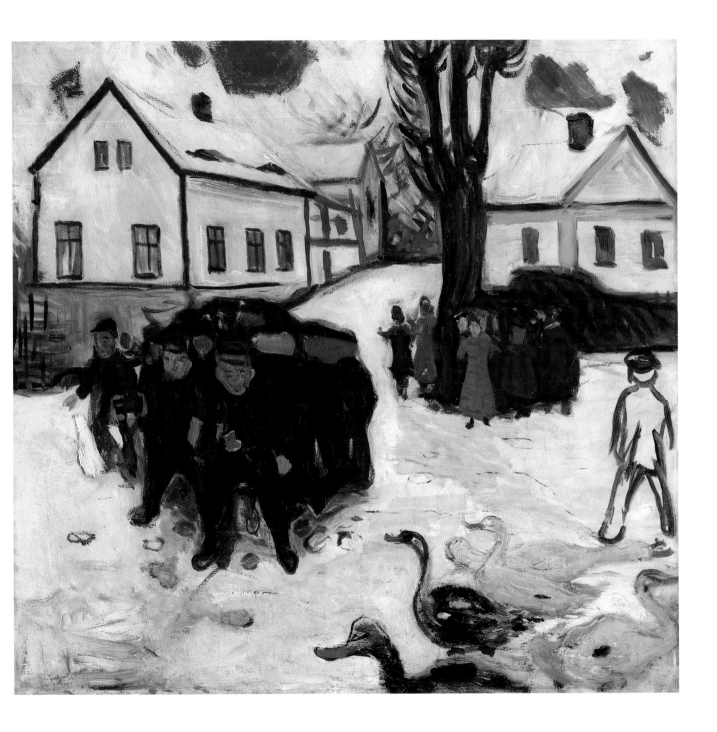

The Village Street, 1905–06
Oil on canvas, 100 x 105 cm (40 x 41 in)
• Munch-museet, Oslo

A painting about the conformity of gender roles in which Munch separates the boys from the girls and leaves a male figure, probably himself, off to the side, not belonging to either group.

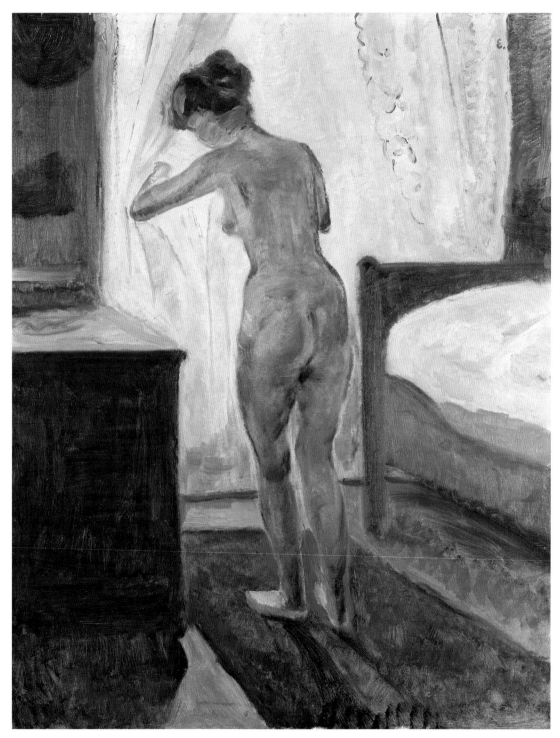

Standing Nude at the Window, 1906
Oil on canvas, 82 x 65 cm (32 x 26 in)
• Private Collection

As if captured in a photograph, a model or Munch's lover has a private moment of observation. We are meant to wonder what she sees.

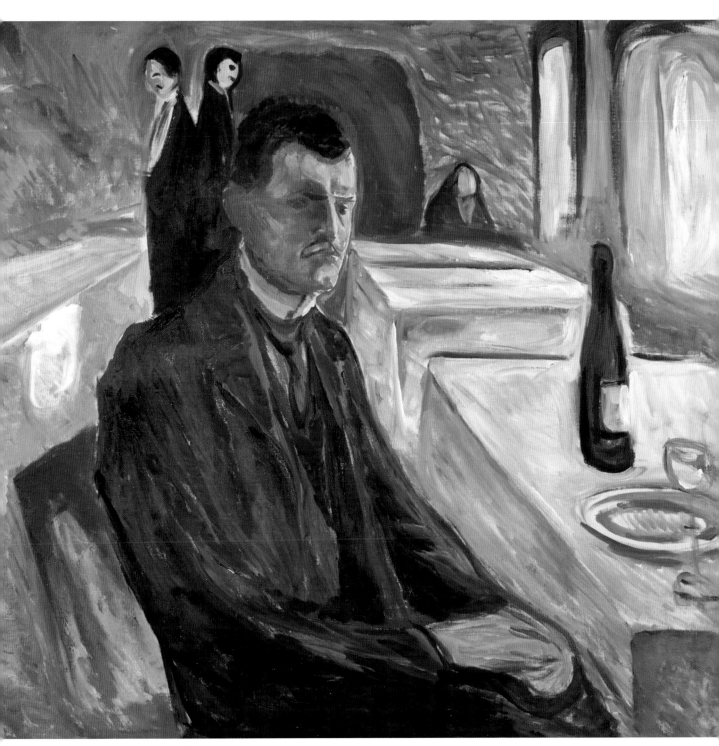

Self Portrait with Wine Bottle, 1906
Oil on canvas, 110.5 x 120.5 cm (44 x 47 in)
• Munch-museet, Oslo

Solemn and pensive, Munch dines alone, disconnected from three people in the background. Though comfortable being alone, the artist was also pained by his isolation.

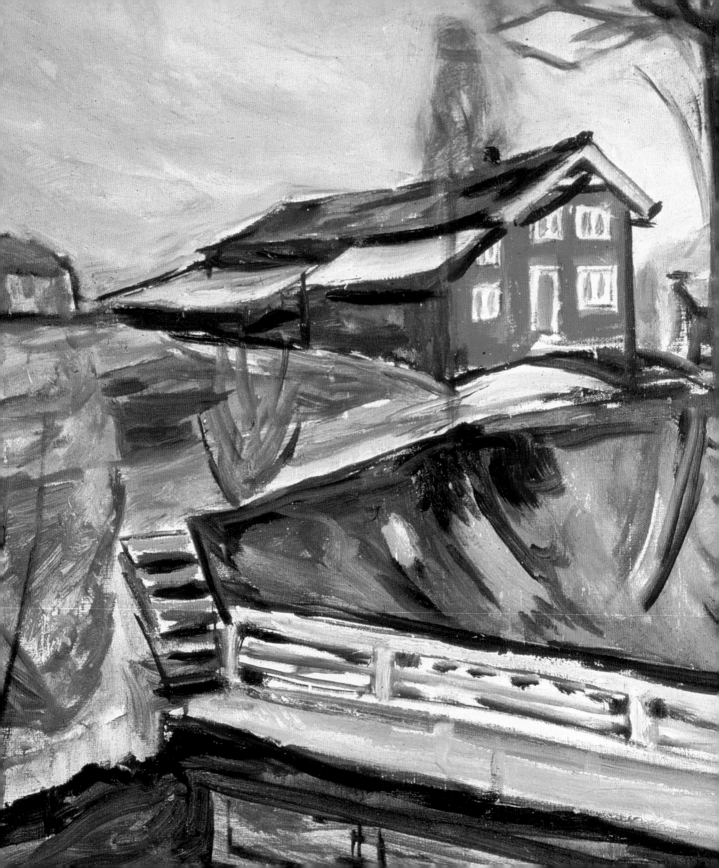

Recovery & Solitude

In 1908 Munch suffered a
nervous breakdown and moved
back to Norway. It was here
that he retired into solitude,
displaying a calmer style of
painting often depicting
landscapes, farm scenes and
figure studies.

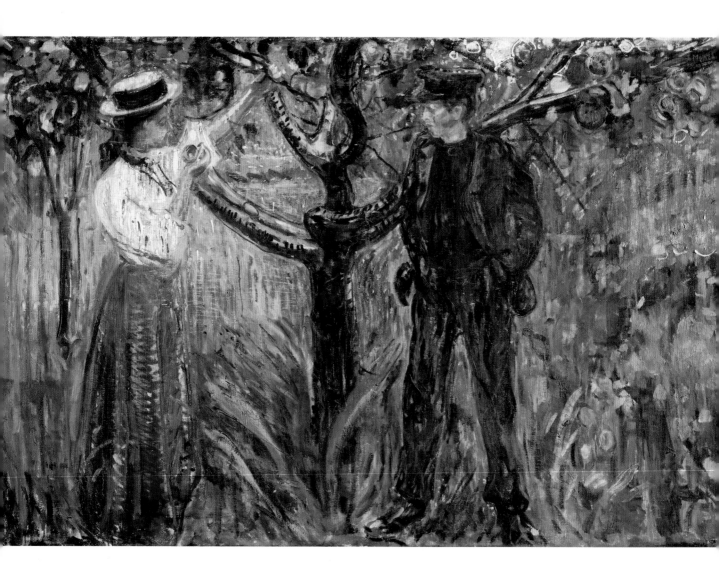

Adam and Eve under the Apple Tree, 1908
Oil on canvas, 130.5 x 202 cm (51 x 80 in)
• Munch-museet, Oslo

Like a contemporary Adam and Eve, this couple is about to eat forbidden fruit and change their fate. Munch was fascinated by this biblical pair, as also seen in *Metabolism* (*see* page 73).

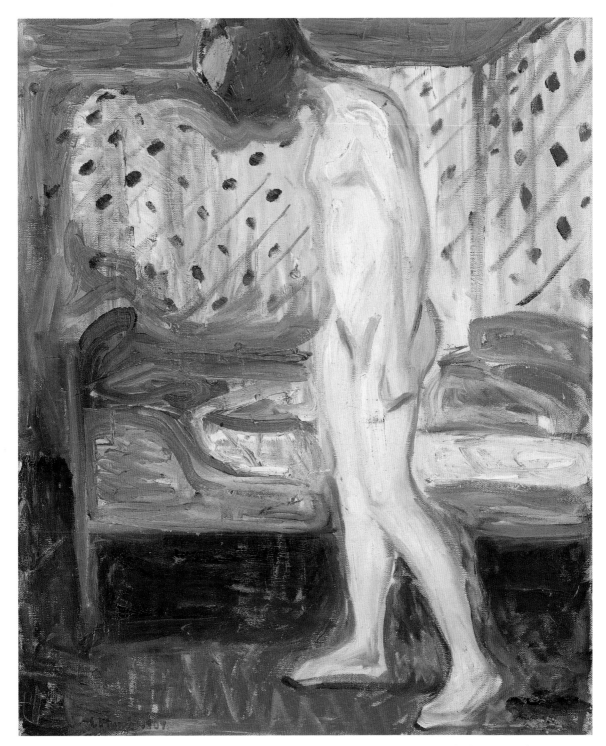

The Crying Girl, 1909
Oil on canvas, 89 x 72 cm (35 x 28 in) • Museum fur
Kunst und Kultur, Westfalisches Landesmuseum, Munster

With the cause of the girl's discomfort unknown, the painting invites speculation
as to whether it is about the changes in her own body as a blossoming adolescent.

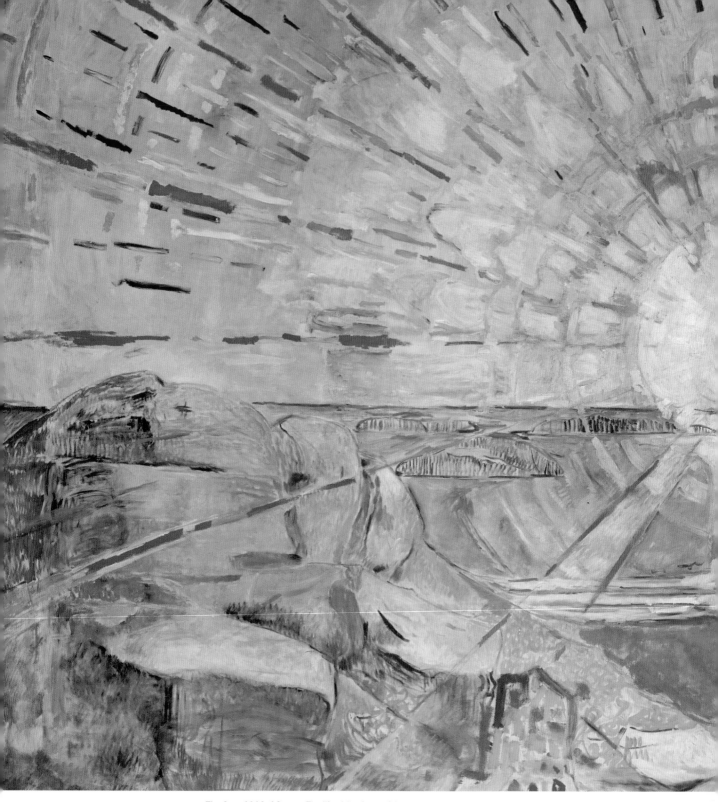

The Sun, 1910–16
Oil on canvas, 455 x 780 cm (179 x 307 in)
• University of Oslo, Oslo

The life-giving force of the universe explodes in a firework radiance of sunbeams cutting across land and sea. It can be seen as a metaphor for ecstasy.

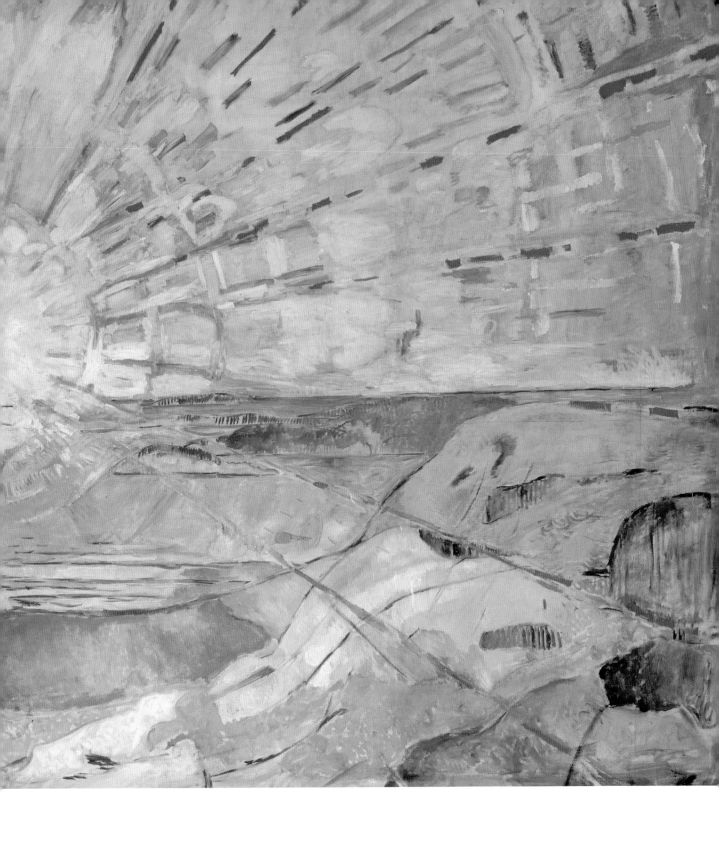

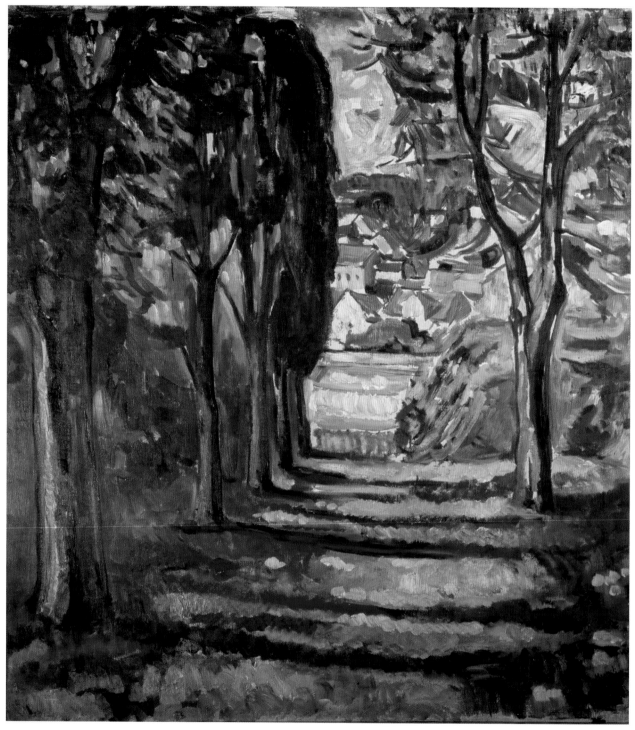

Park in Kragerø, *c.* 1910
110 x 120 cm (43 x 47 in) • Private Collection

A beautiful countryside scene, perhaps showing Munch's more positive outlook. Munch called Kragerø 'the pearl of the coastal towns', finding much inspiration in its landscapes.

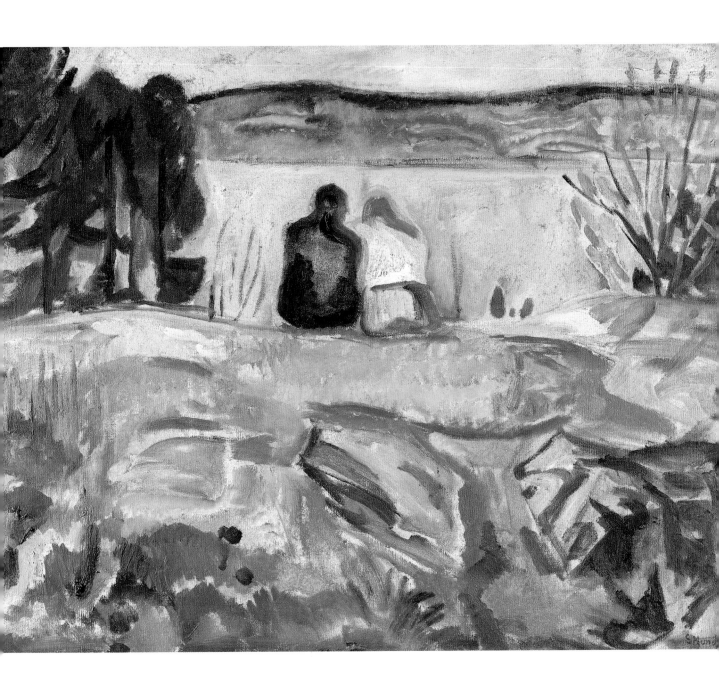

Springtime (Lovers by the Shore), 1911–13
Oil on canvas, 70 x 90 cm (27 x 35 in) • Private Collection

The season of renewal heralds new life and new romance, as a couple sits alone in perfect harmony, away from others. The two represent an ideal of love to which Munch was attracted but also repulsed.

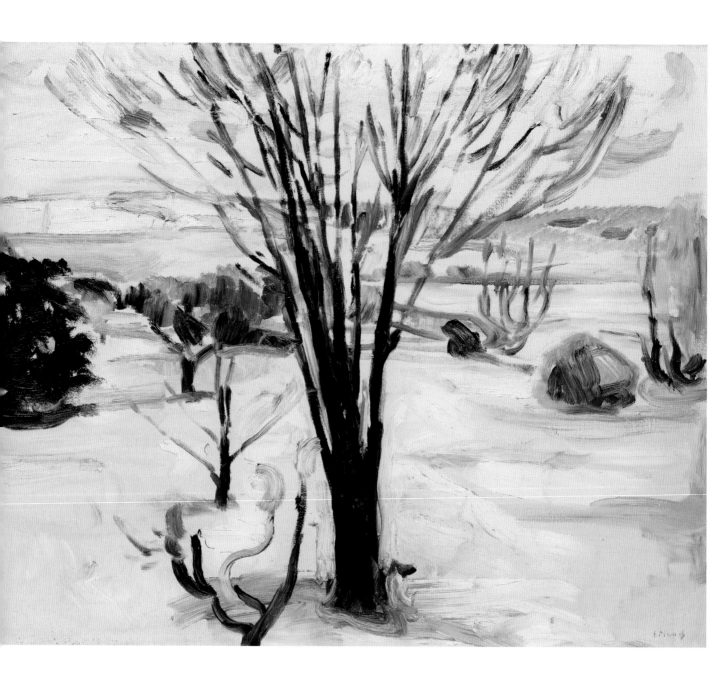

Winter Landscape in Jeloya, 1912
Oil on canvas, 65.4 x 80.2 cm (26 x 32 in)
• Private Collection

The barrenness of this scene suggests spiritual emptiness. The starkness of the leafless tree is a graphic anchor in this desolate landscape, an inescapable feature of Norwegian winters.

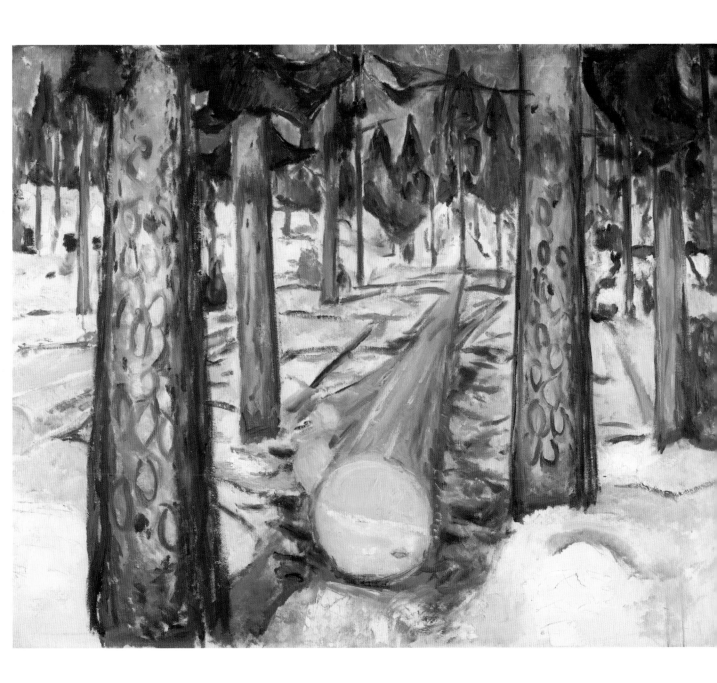

Yellow Log, 1912
Oil on canvas, 129 x 160.5 cm (51 x 63 in)
• Munch-museet, Oslo

At this time Munch was painting several landscape and forest scenes. This painting, in its vivid hues, is one of fascinating perspectives, particularly as the horizontal yellow log narrows into the distance to meet a vertical trunk, pulling our eys into the depths of the forest.

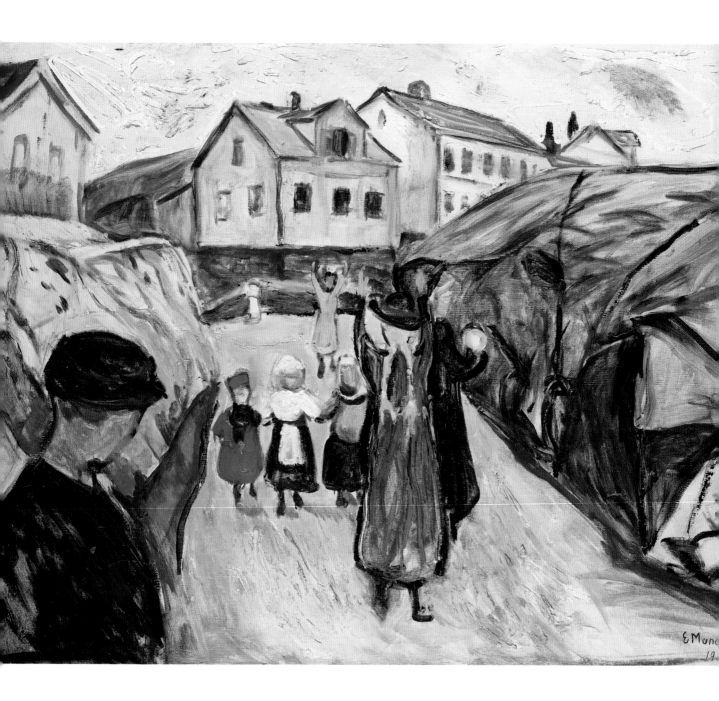

Street in Kragerø, 1913
Oil on canvas, 80 x 100 cm (31 x 39 in)
• Private Collection

Munch first visited Kragerø, on the southern coast of Norway, in May 1909, where he went to recover from a nervous breakdown. This is one of three paintings Munch made of this street between 1911 and 1913.

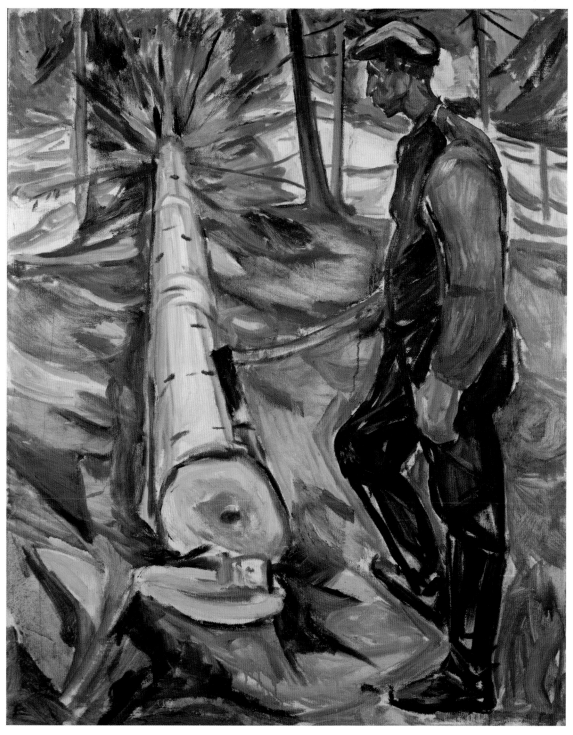

The Lumberjack, 1913
Oil on canvas, 130 x 105.5 cm (51 x 42 in)
• Munch-museet, Oslo

The height and muscularity of the man define his role as worker and provider in gender-segregated Norway a century ago. Munch has moved away from depicting human anguish, but focuses instead on industry and dynamism.

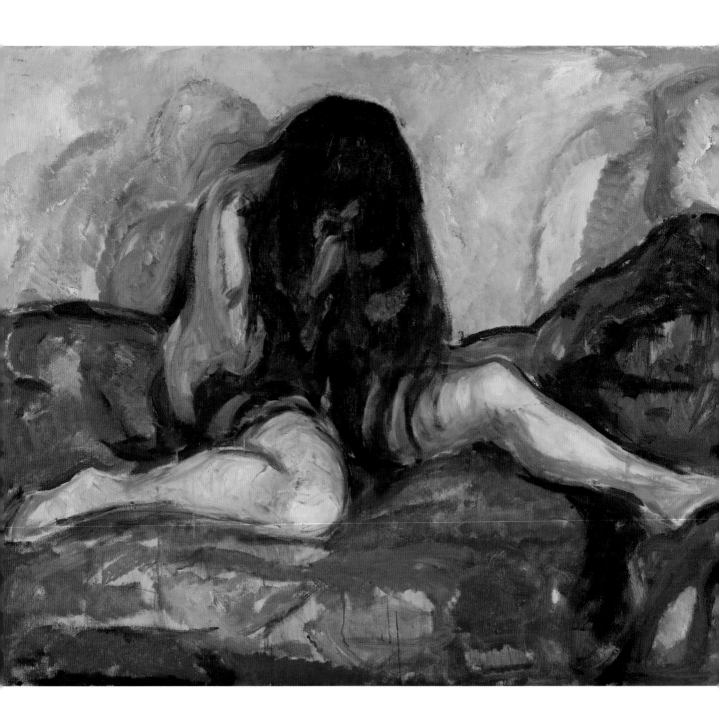

Weeping Nude, 1913–14
Oil on canvas, 110 x 135 cm (43 x 53 in)
• Munch-museet, Oslo

The isolation associated with grief is a recurring theme in Munch's paintings. Perhaps the woman regrets a recent encounter on the bed. Her anguish is increased through the vulnerability of her nakedness.

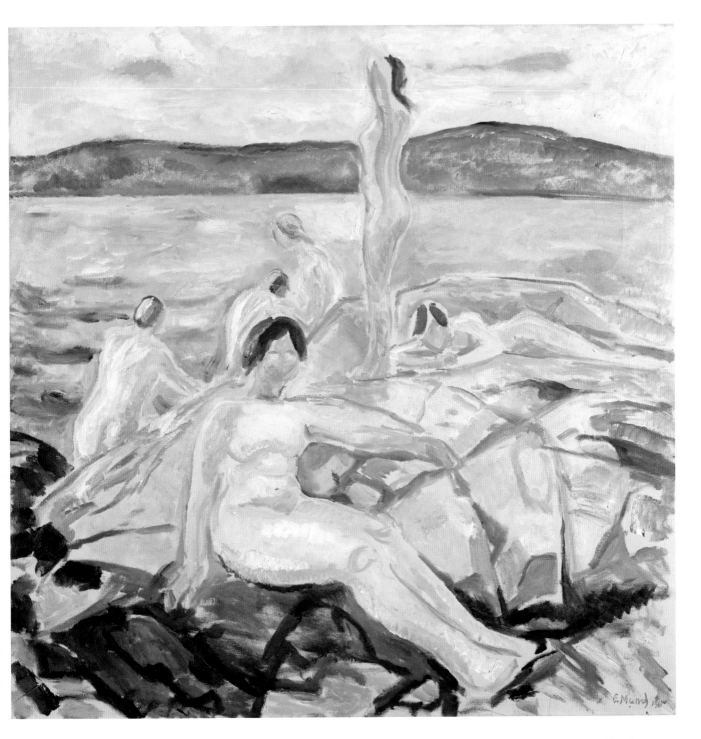

High Summer, 1915
Oil on canvas, 150.5 x 150 cm (59 x 59 in)
• Nasjonalgalleriet, Oslo

Like the carefree nudes of Henri Matisse, these unashamed women represent a man's idea of a joyous sexual paradise. Munch championed free love at a time when Norway was granting women more rights.

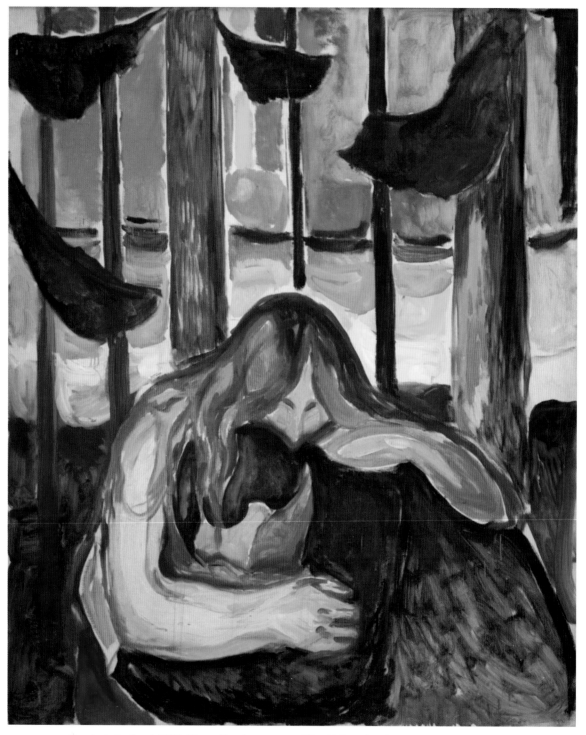

Vampire in the Forest, 1916–18
Oil on canvas, 150 x 137 cm (59 x 54 in)
• Munch-museet, Oslo

Vampires were one of Munch's favourite subjects. As a woman possesses a man in her overpowering embrace, Munch's own vulnerability with women is embodied in the man's submission.

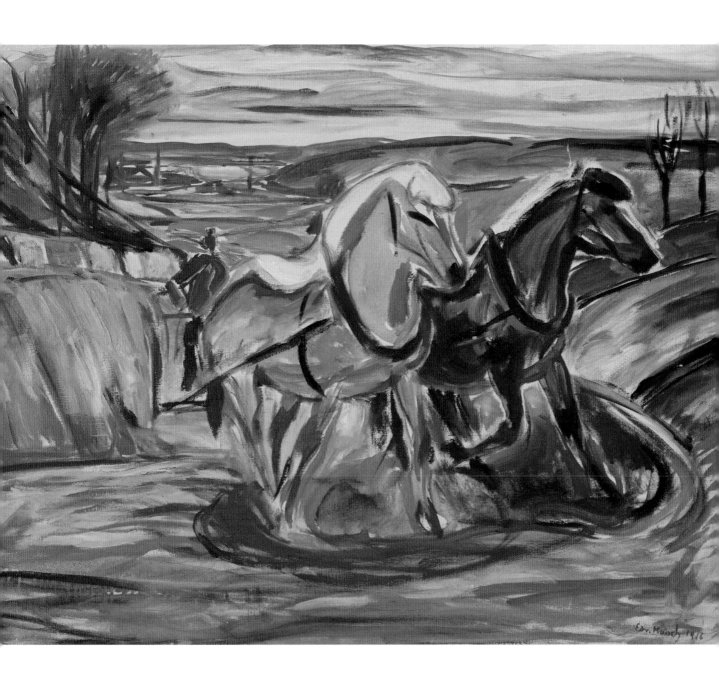

Spring Plowing, 1916
Oil on canvas, 84 x 109 cm (33 x 43 in)
• Munch-Museet, Oslo

The black horse represents darkness and depression while the white horse stands for light and optimism, qualities present in humanity that must be balanced.

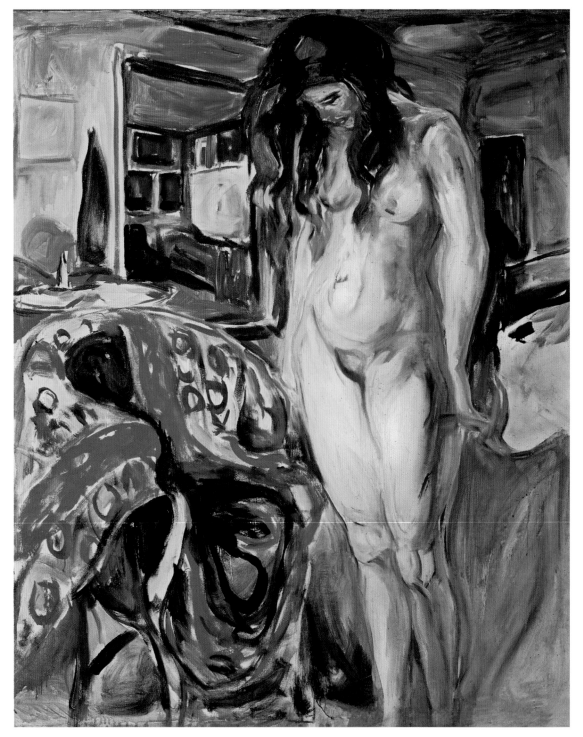

The Artist's Model Standing Beside the Straw Chair, 1919–21
Oil on canvas, 122.5 x 100 cm (48 x 39 in)
• Munch-museet, Oslo

A room suffused with sunlight underscores the woman's dejection after perhaps a night of lovemaking. It is an unstudied pose, a reflective moment. The juxtaposition of the dark colours against her pale skin make her alluring but distant.

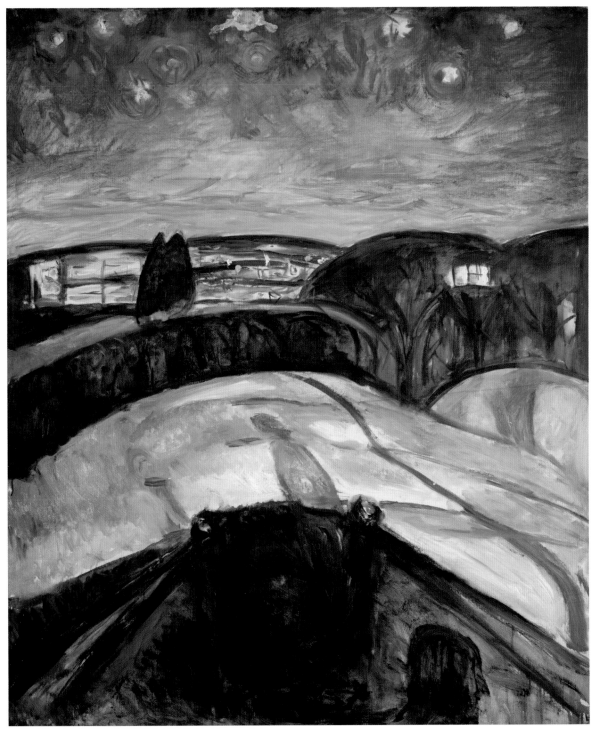

Starry Night, 1923–24
Oil on canvas, 120.5 x 100 cm (47 x 39 in)
• Munch-museet, Oslo

Different planes of colour suggest enormous activity, perhaps from the *aurora borealis*. It bears reference to Vincent van Gogh's same-titled painting of 1889, an expression of mental illness while in an asylum.

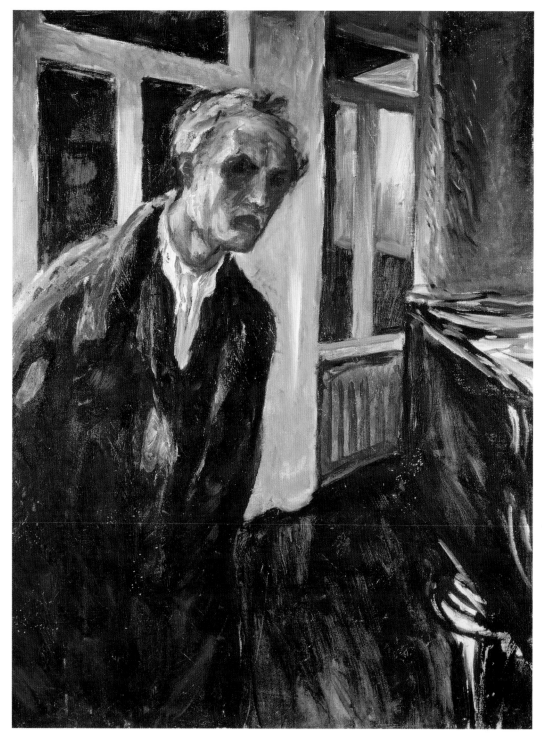

The Night Wanderer, 1923–24
Oil on canvas, 90 x 68 cm (35 x 27 in)
• Kommunes Kunstsamlinger, Oslo

As if startled by a sound, the artist strikes a pose of inquisitiveness in this self-portrait. Riddled by insomnia that appears to have driven him from bed, Munch looks gaunt, his eyes nothing more than black sockets.

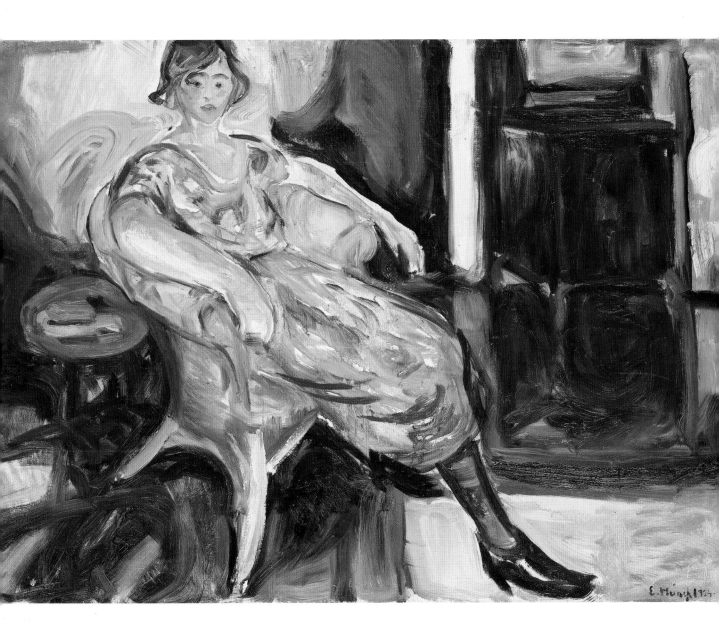

Woman in a Wicker Chair, 1924–25
Oil on canvas, 73 x 100 cm (29 x 39 in)
• Sonia Henie Collection

As if captured in a stolen moment, the woman relaxes while waiting for someone or something
to move her. Munch painted portraits of women he knew personally as well as the professional
models he hired.

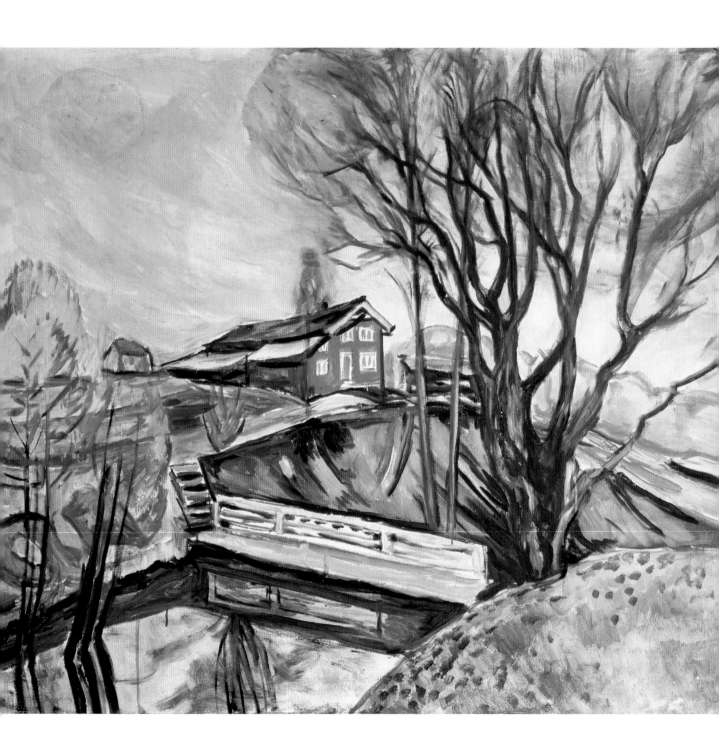

The Red House, 1926
Oil on canvas, 110 x 130 cm (43 x 51 in)
• Nasjonalgalleriet, Oslo

Like a beacon on a hill with a sweeping vantage point, the house represents safety and sanctuary for the artist, who owned several homes and moved frequently.

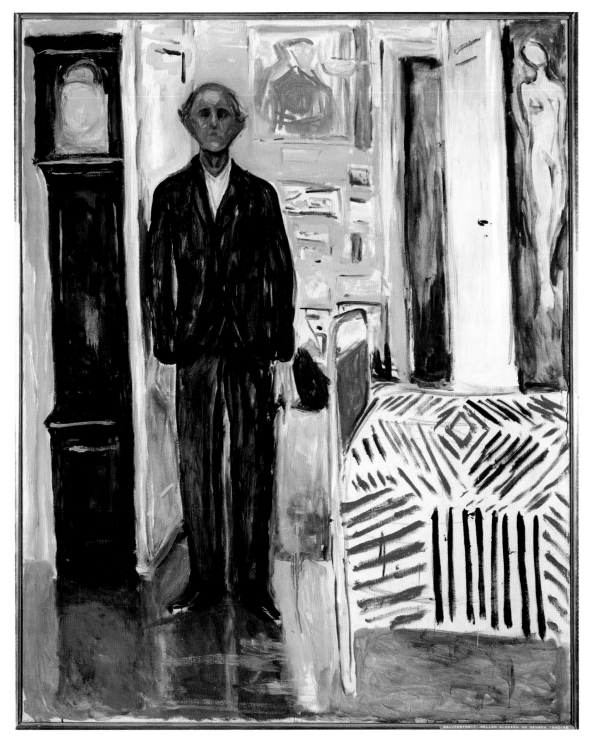

Self Portrait Between the Clock and the Bed, 1940–43
Oil on canvas, 149.5 x 120.5 cm (59 x 47 in)
• Munch-museet, Oslo

In a room with his paintings, a source of pride and reflection, the aging artist stands between his clock – symbolizing time running out – and his bed, presumably anticipating where he would die not long after painting this.

Indexes

General Index

Masterpieces of Art

FLAME TREE PUBLISHING

A new series of carefully curated print and digital books covering the world's greatest art, artists and art movements.

If you enjoyed this book, please sign up for updates, information and offers on further titles in this series at

blog.flametreepublishing.com/art-of-fine-gifts/